IMAGES
of America

CHATHAM

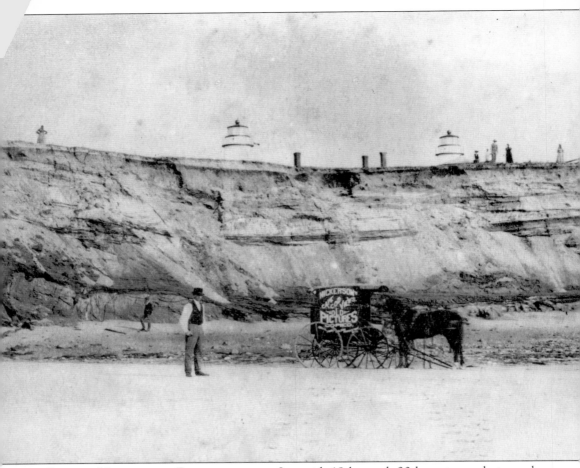

GEORGE NICKERSON, PHOTOGRAPHER. Intrepid 19th- and 20th-century photographers recorded Chatham's history on film. Without people like George Nickerson, shown here with his traveling photography studio (his horse and cart), we would not be able to picture life as it was back then. Nickerson is shown at the bottom of James Head bluff with the twin Chatham Lights, built in 1840, in the background. (Courtesy of the Chatham Historical Society.)

On the cover: Rosella Franklin Rich Bearse, formerly of Truro, and husband Isaac Albert Bearse are seen in this view with two of their children—daughter Susan and son Benjamin Franklin—at the Bearse homestead in South Chatham off what is now Dusty Miller Road. The family portrait was taken in the early 1900s. (Courtesy of Fred H. Bearse.)

IMAGES
of America

CHATHAM

Janet M. Daly

ARCADIA

First printed in 2002.

Published by Arcadia Publishing,
an imprint of Tempus Publishing, Inc.
2A Cumberland Street
Charleston, SC 29401

Printed in Great Britain.

Library of Congress Catalog Card Number: 2001098828

For all general information contact Arcadia Publishing at:
Telephone 843-853-2070
Fax 843-853-0044
E-Mail sales@arcadiapublishing.com

For customer service and orders:
Toll-Free 1-888-313-2665

Visit us on the internet at http://www.arcadiapublishing.com

*This book is dedicated to my husband, Alan F. Daly,
"my hero" and the "wind beneath my wings."*

CONTENTS

ACKNOWLEDGMENTS

I appreciate the support of Spencer Grey, president of the Chatham Historical Society. My deep thanks go to Florine and Dwight Myers for their unselfish availability and assistance during my viewing of the photographs at the Atwood House, home of the Chatham Historical Society. The Nickerson Family Association and Burton N. Derick were supportive and helpful in my research attempts. Loving thanks go to Fred H. Bearse for sharing recollections and photographs of his family and South Chatham. To Linda Bearse Goodspeed, Frank Hutchings, Floy Rowland Eilers, and Eileen MacDonald Moore, I extend my gratitude for opening their homes and sharing their memories and family photographs with me. I am grateful to Joan Mahoney, historian of the Chatham Woman's Club, whose work with me in preparing the video history of the club whetted my appetite to learn more about the men and especially the women who made Chatham what it is today. To all listed above, as well as the many lifelong Chatham residents, especially Joe Nickerson, and newcomers who reminisced with me and shared photographs of their Chatham memories, I give my heartfelt thanks.

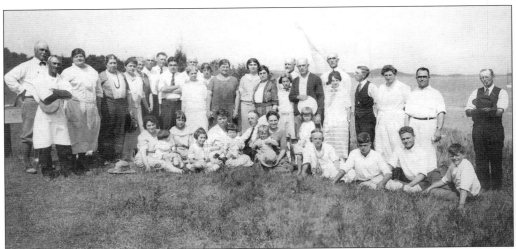

A NICKERSON FAMILY CLAMBAKE. Nickerson is *the* name to remember in Chatham's history. The founding family of Chatham was William Nickerson and wife Anne Busby Nickerson. Nickerson purchased land from Mattaquason, the sachem of the Monomoyicks, in 1658. Pictured is Carroll Nickerson's family at a clambake on Pleasant Bay in the 1920s, close to where his ancestors lived and founded Chatham. (Courtesy of the Nickerson Family Association.)

INTRODUCTION

This book presents a view of Chatham from the early days of photography to Chatham's 250th anniversary celebration in 1962. Photographers—both professional and amateur—focused during these almost 100 years on the men and women of Chatham. The photographs show who they were, where they lived, and what they did. *Chatham* does that, too.

Certainly, Chatham is a beautiful place to live and visit, but what makes Chatham truly special are the people who settled here, raised families, worked, and worshiped here. Chatham is made up of five villages: Chatham, Chathamport, North Chatham, South Chatham, and West Chatham. Each village has its special flavor.

Chatham is off by itself; it is an outpost. Located at the elbow of the bent arm of Cape Cod, Chatham is about as far east as you can live in the United States. It has shoreline on the Atlantic Ocean and Nantucket Sound, and the sea has always played a key role in the town. Ship captains, sailors, and fishermen have plied the waters surrounding Chatham, aware of the treachery of its shoals and sandbars. Hundreds of ships have gone aground and been wrecked in the waters around Chatham.

In 1808, the first Chatham lighthouse was built to warn ships of the dangerous waters. There have been two other pairs of lighthouses built since then because James Head, on which the lighthouses stand, has felt the wrath of Atlantic storms and almost ceaseless winds. Chatham residents manned the lighthouses and were the lifesaving teams who rescued the victims of shipwrecks, nursed the injured, and buried the dead. Adjacent to the present Chatham Light and behind the Mack Monument, which commemorates the rescue attempt of the barge *Wadena,* lies a burial ground for 106 unknown sailors.

However, there is another side to the ocean and bays of Chatham. Swimming and bathing in these beautiful waters have been popular since late 1800s. Boating was popular even before that, especially in the more protected waters of Pleasant Bay, Stage Harbor, and Oyster Pond. Today, sailboats, fishing boats, and powerboats dot the harbors of Chatham, awaiting the hundreds who crave a day on the water. Sportsmen have found the area a paradise. The Brant Club on Monomoy Island and other sporting lodges provided great rewards to hunters and fishermen. Walkers, bikers, and even the horsey set have found Chatham to their liking.

Chatham became a resort to house these visitors as transportation and technology improved. Vacation homes and farms were built by the wealthy around the beginning of the 20th century, as were many rambling hotels and inns. Some have survived and others have not, but their glory remains in the wonderful photographs of times gone by. The lifestyles of the rich and famous are richly recorded in photographs of their homes and their celebration of the town's 200th anniversary. Many of Chatham's summer residents have left lasting memorials to their love for this town. Marcellus Eldredge endowed both the Methodist church and the town library, now the Eldredge Public Library. Avis Chase, born in Chatham but a Philadelphia socialite in later life, donated Chase Park to the town in memory of her beloved husband.

Chatham's location, jutting as it does into the Atlantic, made it ideal as an intercontinental radio transmission station. Marconi (later RCA and then MCI) wireless installations still mark the landscape in Chathamport. When World War I came, Chatham became a station for blimps and seaplanes designed to protect shipping lanes from German submarines. The Chatham Naval Air Station was located on the same neck of land named for Chatham's first European settler, William Nickerson. During World War II, Monomoy Island was the site for naval activity designed to keep the sea lanes safe for the Allies. These momentous times left their mark on Chatham.

Yet, every day throughout the past 100 years, Chatham residents have led everyday lives. Some were traditionally American; others were unique and very special. Children went to school, parents went to work, and both worshiped on Sundays and played whenever they could. The schools and businesses, churches, organizations, and teams, which were part and parcel of Chatham family life, are recorded for posterity by the camera.

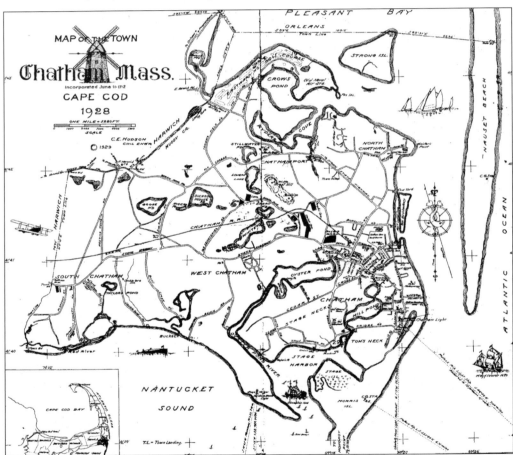

CHATHAM, 1928. Settled in 1664, Chatham was formerly the Native American village of Monomoit. Arthur W. Tarbell writes, "Chatham is the town that was bought with a boat, being the scene of an interesting little real estate transaction in 1658. To bind a bargain, its first white settler, William Nickerson, a weaver from Norfolk, England, gave a shallop to the sachem Mattaquason." Tradition locates Nickerson's homestead near the head of Ryder's Cove, very near to where the current Nickerson Family Association has its headquarters. Part of Nauset Beach and Monomoy Island, extensions of Chatham, have borne the brunt of wind and waves and change from map to map as time goes by. (Courtesy of the Chatham Historical Society.)

One
THE EARLY DAYS

All these early settlers were tillers of the soil. They settled for the most part near the shore for convenience in getting shellfish and other fish for family use, but they devoted their lives to agriculture.

—William C. Smith, *Chatham*

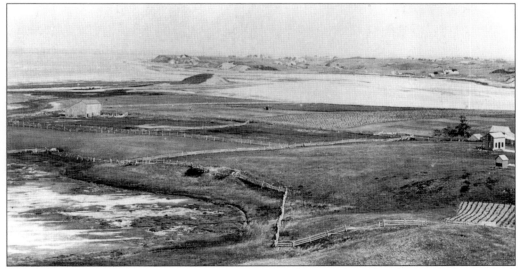

ENSIGN NICKERSON'S FARM. The Nickersons, from William on through to his descendant Ensign, farmed the neck bearing their family name. This photograph from the 1880s looks out to Bassing Harbor on the left and Crow's Pond on the right. Note the absence of trees in the area. Farmers had cut them down for growing and grazing. (Courtesy of the Chatham Historical Society.)

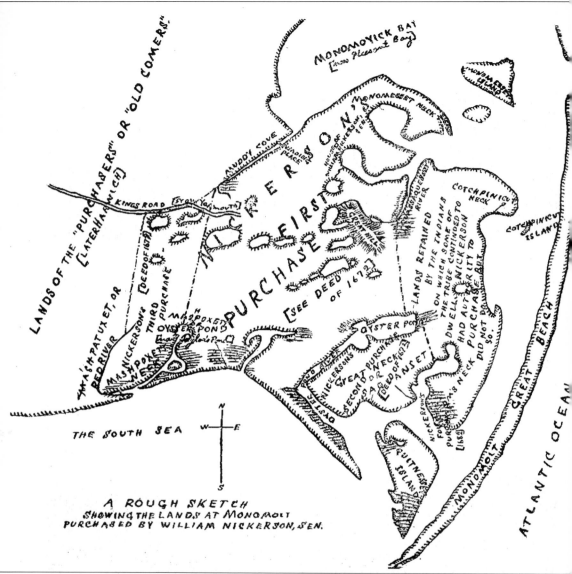

Map labels: LANDS OF THE "PURCHASERS" OR "OLD COMERS" · MONOMOYICK BAY [now Pleasant Bay] · MONOMOY ISLAND · [LATER HARWICH] · KINGS ROAD [S. YARMOUTH] · MUDDY COVE · TRADING PLACE · NICKERSON'S FIRST PURCHASE · MONOMESSET NECK · COTCHPINICUT NECK · COTCHPINICUT ISLAND · [SEE DEED OF 1672] · OYSTER POND · OASHPATU ET, OR RED RIVER [DEED OF 1678] · NICKERSON'S THIRD PURCHASE · MASHPOXET OYSTER POND [now Lover's Pond] · MASHPOXET NECK · OYSTER POND · NICKERSONS SECOND PURCHASE OR GREAT PURCHASE [DEED OF 1672] · GREAT NECK · DEANSET · LANDS RETAINED BY THE INDIANS ON WHICH SOME OF THE TRIBE CONTINUED TO DWELL. NICKERSON HAD AUTHORITY TO PURCHASE, BUT DID NOT DO SO. · NICKERSONS FOURTH PURCHASE OR TOM'S NECK [1682] · THE SOUTH SEA · N W E S · QUITNESS ISLAND · MONOMOIT GREAT BEACH · ATLANTIC OCEAN · A ROUGH SKETCH SHOWING THE LANDS AT MONOMOIT PURCHASED BY WILLIAM NICKERSON, SEN.

WILLIAM NICKERSON'S PURCHASE. This sketch shows the lands at Monomoit purchased by William Nickerson and refers to the deed of 1672, signed by Mattaquason and his son John Quason. All the land comprising the present town west of Frost Fish Creek, the head of Oyster Pond, the Mill Pond, and all the meadowland on Tom's Neck (more than 4,000 acres) was owned by William Nickerson. The Native Americans retained the rest of the land. The only road shown on the map is Kings Road, which went to South Yarmouth where Nickerson had lived. Perhaps even more interesting than the boundaries of Nickerson's land purchase is the configuration of Monomoit Great Beach, what we now call North Beach. Quitnesset Island, now Morris Island, was completely separate from the rest of Monomoit, as Chatham was called then. (Map from *Chatham*, by William C. Smith; courtesy of the Chatham Historical Society.)

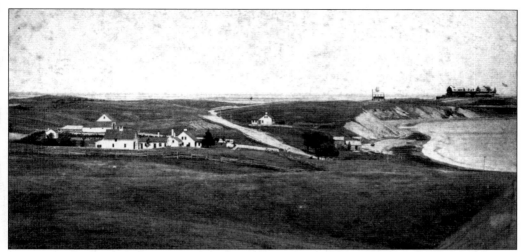

NICKERSON NECK, C. 1890. Ensign Nickerson's farm is on the left. The winding road leads to the Hotel Chatham, visible in the background on the far right. The hotel opened on June 30, 1890. It was built by Chatham-born Marcellus Eldredge, whose family moved to New Hampshire, where he became a successful businessman. His partners were his brother H. Fisher Eldredge and Eben Jordan of Jordan Marsh fame. (Courtesy of the Chatham Historical Society.)

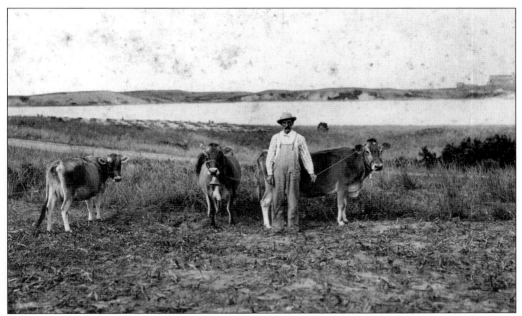

A MAN WITH THREE COWS. Agriculture remained an occupation for many years in Chatham throughout the 19th century. This Chathamport farm worker stands on Eldredge Neck, probably on H. Fisher Eldredge's farm. Behind him is Crow's Pond, and on the far right is the Hotel Chatham, which cost more than $100,000 to build. It closed after only four seasons of service and, about 15 years later, was torn down. (Courtesy of the Chatham Historical Society.)

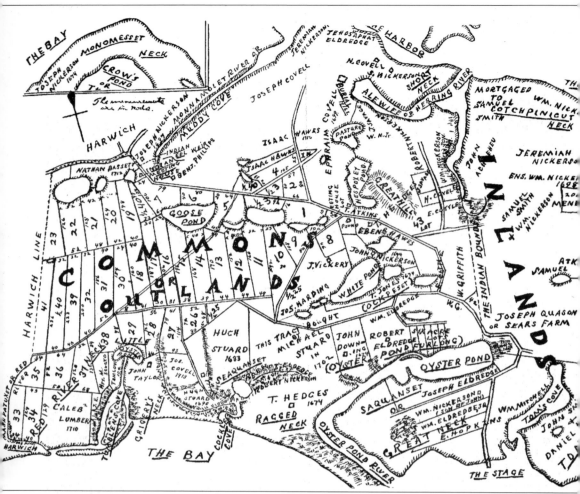

CHATHAM'S EARLY SETTLERS. This map shows where Chatham's pioneer families lived. Names found in today's telephone books are listed on this map. Eldredge, certainly a major family name in Chatham's history, is found on this map. William Nickerson's daughter Elizabeth married Robert Eldred, later corrupted to Eldredge. There is also a Jehosaphat and a Joseph Eldredge listed. Other family names still represented in Chatham are Hawes, Bassett, Harding, Vickery, Smith, Hamilton, and Taylor. The Common Lands, as marked on the map, are areas that early settlers had purchased, while the Inlands were lands belonging to the Native Americans. On June 11, 1712, Governor Dudley of Massachusetts signed an order "that the Village or District now called Monomoit be erected into a Township and the Town named Chatham." Several other Cape towns had been named for English towns, and that was probably why the name was chosen by the people of Monomoit. Chatham, England, was a naval station, and some may have hoped the American counterpart might be one too. (Map from *Chatham*, by William C. Smith; courtesy of the Chatham Historical Society.)

ON PLEASANT BAY. As the Nickerson clan grew, they spread along the shores of Pleasant Bay into East Harwich. On the far right is Warren and Jane Nickerson's homestead, overlooking Round Cove. Later the home of T. Carroll and Emma Nickerson, the homestead is now the site of the Wequassett Inn. The catboat on the far left belonged to T. Carroll Nickerson. (Courtesy of the Nickerson Family Association.)

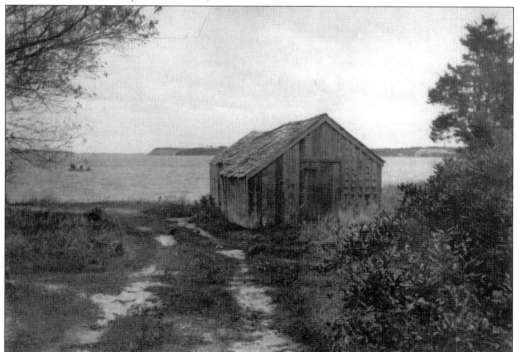

FISH SHACKS ON PLEASANT BAY. T. Carroll Nickerson line-fished for cod offshore from Chatham Light almost daily from spring to fall. Cod was salted and stored in barrels in shacks like these for pickup by wholesalers. Just as the abundance of shell and fin fish sustained the original Nickersons, it supported succeeding generations, too. (Courtesy of the Nickerson Family Association.)

13

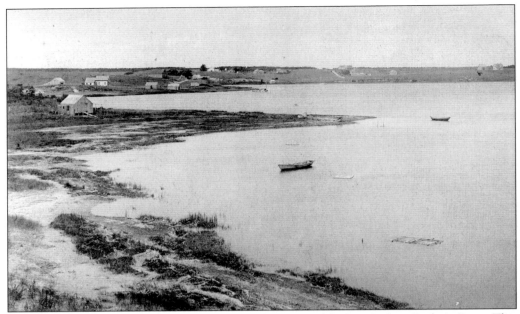

RYDER'S COVE. South of Nickerson Neck, sheltered by Eldredge Neck, is Ryder's Cove. This photograph, taken from where the present-day boatyard is, shows a few homes and fishing shacks. The road to Orleans, Route 28, winds its way up the hill in the center of the photograph. Capt. Christopher Ryder's home is located to the right on the rise of the hill. (Courtesy of the Chatham Historical Society.)

A QUIET MOORING. Ryder's Cove was named for early settler Reuben Ryder, who had a saltworks on its shores. Quiet inlets, such as Ryder's Cove, are often too shallow to be considered harbors but are ideal refuges for catboats to anchor. Small fishing shacks line the shore. Today, the cove is filled with boats, and many homes dot the shoreline. (Courtesy of the Chatham Historical Society.)

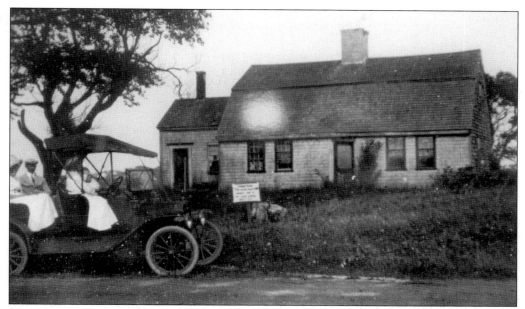

CHATHAM'S OLDEST HOUSE, C. 1900. The Atwood House, now a local museum and site of the Chatham Historical Society, was built c. 1752 as the home of Deborah and Joseph Atwood. In 1923, the Chatham Historical Society was founded by a group of women from the Ladies Reading Society. The house was acquired and refurbished shortly thereafter. (Courtesy of the Chatham Historical Society.)

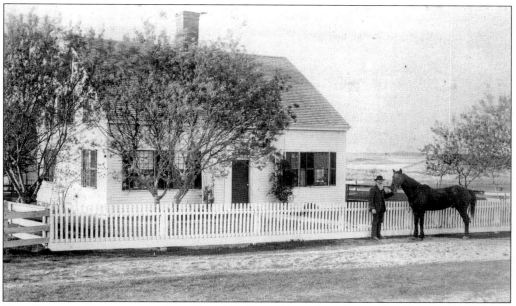

THE CROWELL HOMESTEAD. Capt. David H. Crowell stands in front of his home with his horse Charley. In 1717, the captain's forefather Paul Crowell purchased land on Nickerson Neck. In those days, the Crowells pronounced and often spelled their name as "Crow." Once known as the Harbour because it was a haven for ships, the pond was known as Crow's Pond by 1795. (Courtesy of the Chatham Historical Society.)

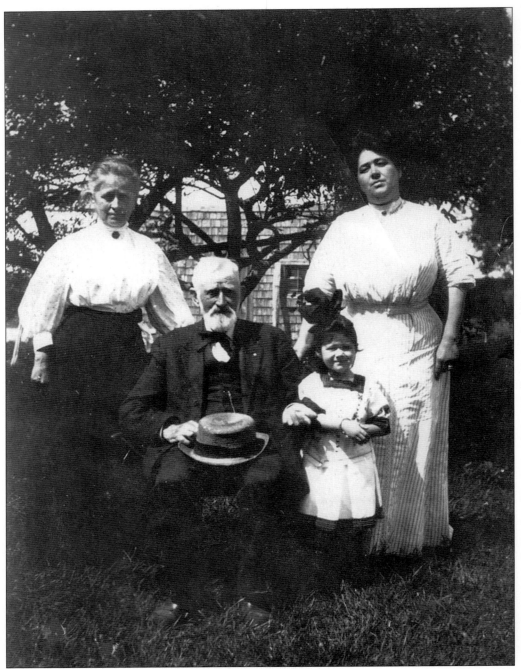

A FAMILY TABLEAU. Four generations pose for a photograph in Chathamport. Capt. David H. Crowell, seated, is shown with daughter Mary Crowell Farmer, great-granddaughter Virginia Harding, and granddaughter Edith Farmer Harding. Edith Harding (Mrs. Heman Harding) was twice president of the Chatham Woman's Club, and a scholarship is awarded each year in her memory by the Massachusetts Federation of Women's Clubs. (Courtesy of the Chatham Historical Society.)

A NICKERSON HOMESTEAD. Caleb Nickerson and his wife, Julia Ann Hamilton, lived with their family in this North Chatham home. Caleb Nickerson was the keeper of a refuge hut located between Nauset and Chatham Harbors. The huts were built by the Boston Marine Society on the barren shores from Boston to Cape Cod to give shelter to survivors from wrecks. (Courtesy of the Nickerson Family Association.)

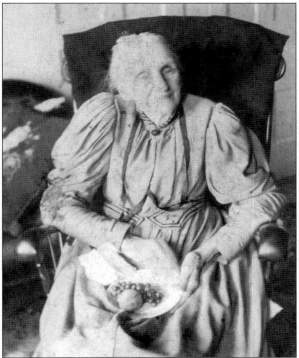

JULIA ANN NICKERSON. Julia Ann Nickerson, née Hamilton, was a survivor. This photograph taken at a family get-together shows a lovely, smiling woman in her rocking chair c. 1900. Nickerson was born on August 1, 1817, and died on January 20, 1905. She must have seen dramatic changes in Chatham as it grew from a barren outpost to a destination resort. (Courtesy of the Nickerson Family Association.)

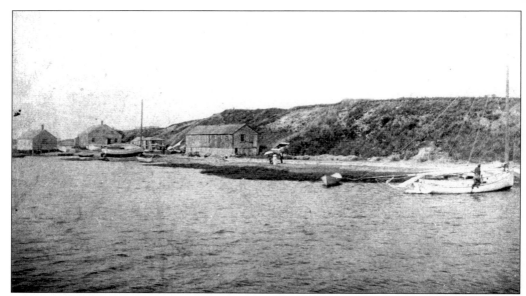

STAGE HARBOR, C. 1880. Stage Harbor was a working harbor in the 19th century. Fishing shacks for dried fish and other storage dotted the shore, as well as workboats of the era. A pier at the foot of Champlain Road was where steamboats from New York, Nantucket, and New Bedford came into Chatham. The railroad displaced the passenger and cargo boats c. 1896. (Courtesy of Fred H. Bearse.)

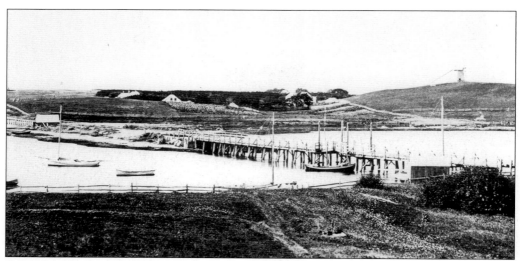

THE MITCHELL RIVER BRIDGE. The bridge connects Tom's Neck with the rest of Chatham and crosses the Mitchell River, which connects the Mill Pond with Stage Harbor. It was built in 1854 and named for William Mitchell, an early settler. It is the only drawbridge in town and allows access to the Mill Pond boatyard. In the background on the far right is the Godfrey Mill. (Courtesy of the Chatham Historical Society.)

Two
CHATHAM'S LIGHTHOUSES

*A lighthouse is something more than a decoration for these waters,
and there have been lights on the bluff since 1808; but the sea
has come in after them, bringing one down every few decades.*

—Joseph Berger (Jeremiah Digges), *Cape Cod Pilot*

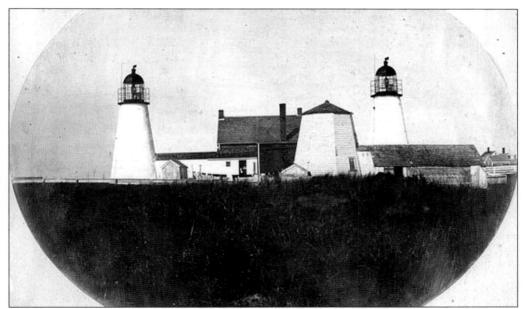

A TRACE OF THE 1808 LIGHTHOUSE? This rear view of the 1840 lights shows an octagonal wood structure. Tradition has it this was part of the 1808 towers, which were 43 feet high. The first keeper of the 1808 Chatham Light was Samuel Nye. The towers of the 1840 lights were attached on either side of the keeper's house. Its three chimneys are distinct. (Courtesy of the U.S. Coast Guard Historian's Office.)

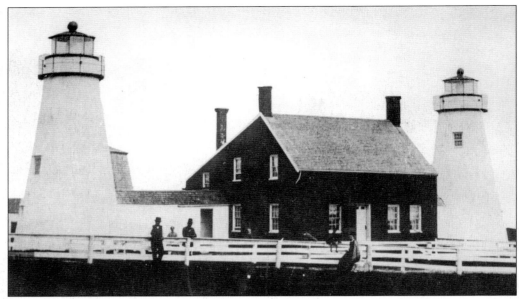

THE 1840 CHATHAM LIGHT. In 1808, two towers were designed to distinguish Chatham from the single Highland Light, built in Truro in 1797. The first Chatham Lights were wooden towers. In 1840, this second pair was made of brick. Collins Howes was their first keeper, followed by Simeon Nickerson. His wife, Angeline Anderson Nickerson, served as keeper from 1848 to 1862 following his death. (Courtesy of the Chatham Historical Society.)

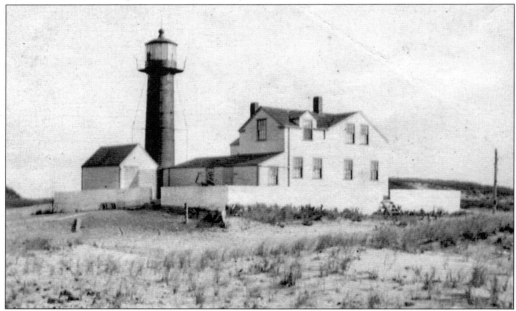

THE MONOMOY POINT LIGHT. In 1823, Chatham got another lighthouse, a red iron tower on South Monomoy Island. Monomoy is a "spit of land whose shape and size changes at the whim of winds and tides. That's why the shipmasters desperately needed a lighthouse there," writes Donald W. Davidson in *America's Landfall*. Deactivated in 1923, it is now located within the Monomoy National Wildlife Refuge. (Courtesy of the Chatham Historical Society.)

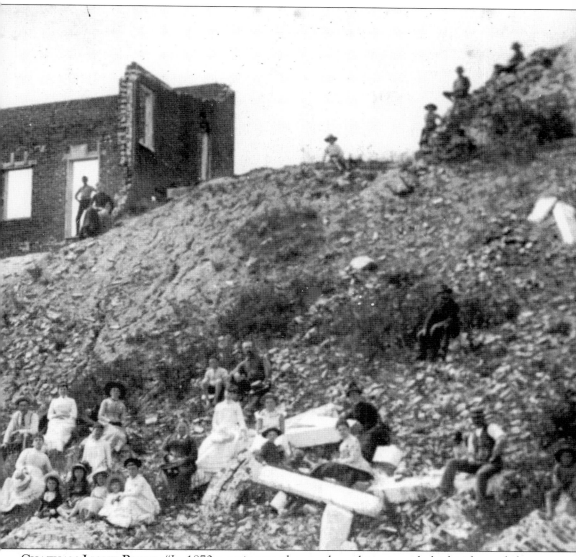

CHATHAM LIGHT RUINS. "In 1870 a raging northeaster brought extremely high tides and the sea broke through the outer beach. At that time the twin brick lighthouses stood 228 feet from the edge of the 50-foot bank, but from then on every northeasterly or easterly storm chewed away a chunk of the bank," writes Scott Corbett in *Cape Cod's Way*. In 1872, Josiah Harding II was named Chatham Light's keeper. During his 28 years of service, he kept a diary. Harding noted in his log that in November 1874, the bluff had suffered more erosion in a storm. The following month, he measured the distance from the south tower to the edge of the bank. It was 190 feet. In four years, 38 feet had been swept away by sea and wind. It took the government three years to build two new towers and activate them. By 1880, the old keeper's house and old north tower were in ruins at the top of the bank. Townsfolk and visitors picnicked among the ruins. (Courtesy of the Chatham Historical Society.)

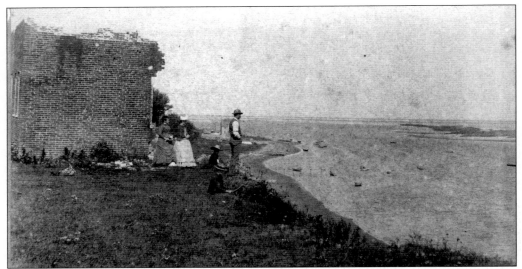

THE CHATHAM LIGHT KEEPER'S HOME. Men and women stand around the ruins of the Chatham Light keeper's home on the crumbling bluff. Only flats are visible just below the bluff, but some fishing shacks are still intact beyond. To the right, there are only shoals and bars visible. In 1881, Josiah Harding reported the opening to the Atlantic Ocean was one mile long. (Courtesy of the Chatham Historical Society.)

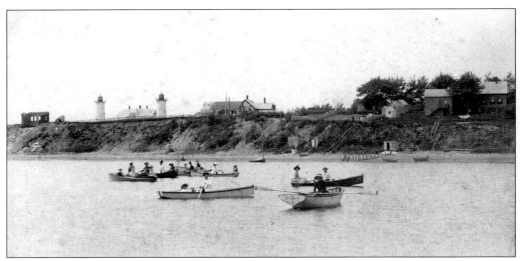

ENJOYING THE VIEW. The Chatham Lights have been of interest since they were first built. Here, Pleasant Bay boaters enjoy the view. In the background are the keeper's house and the north tower ruins on the far left. The twin lights and keeper's house are visible, too. In the center right are at least three structures still standing in today's Old Village. (Courtesy of the Chatham Historical Society.)

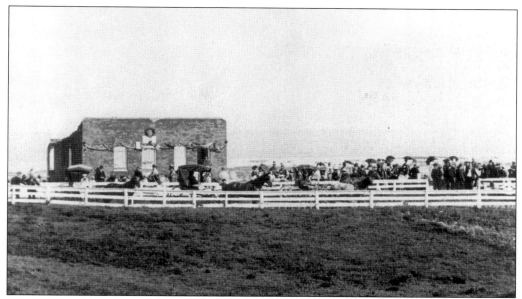

CHECKING THE SCENE. The ruins of the keeper's house are right on the bank, showing how little of the bluff remains. Since there are garlands and a wreath decorating the house and dozens of people and buggies gathered nearby, perhaps this is the conclusion of a 1880s Fourth of July parade at Main Street's end. Today, people still flock to inspect this ever changing view. (Courtesy of the Chatham Historical Society.)

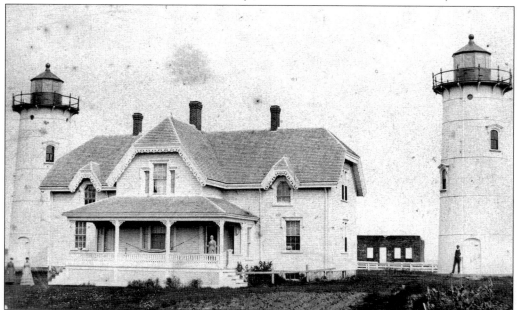

CHATHAM'S THIRD SET OF LIGHTS. Keeper Josiah Harding poses at the south tower. His wife stands on the front porch of the house, which you will notice now faces away from the water. The old keeper's house is visible between the house and south tower. The new lights were lit in May 1877, and the house was ready for the Harding family in November. (Courtesy of the Chatham Historical Society.)

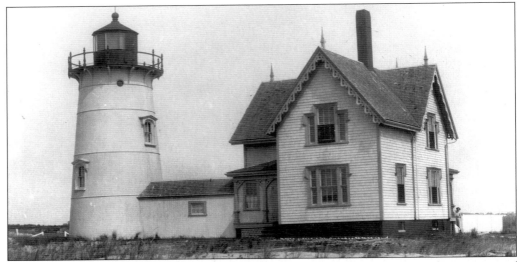

THE STAGE HARBOR LIGHT. Located on Harding's Beach at Inward Point, the entrance of Stage Harbor, this third Chatham lighthouse was built in 1880 of cast iron. The keeper's house and tower are shown *c.* 1925. It operated until 1933, when it was deactivated and the turret removed. It was sold to the Hoyt and Ecker families in 1935 and remains today as a private home. (Courtesy of the author's collection.)

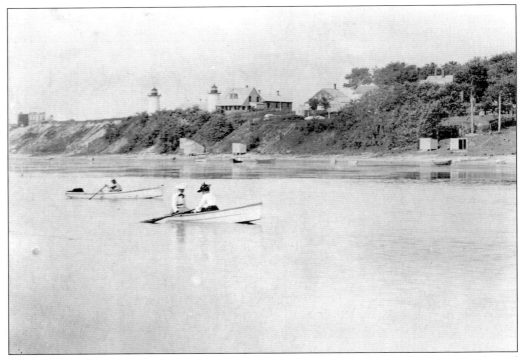

ROW, ROW, ROW YOUR BOAT. In the 1890s, when this photograph was taken, women dressed in long skirts and wore hats always. That did not seem to hamper their activities. Getting out on the water and rowing near the twin lights was an enjoyable summer pastime for women and a nice break from household duties. (Courtesy of the Chatham Historical Society.)

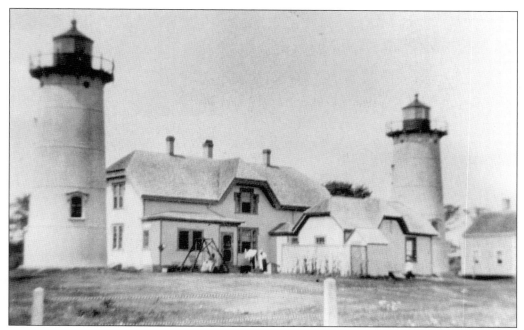

FAMILY LIFE AT THE LIGHTS. While today this is the front yard of the U.S. Coast Guard Station Chatham, it was the backyard in the early 20th century. A wooden swing keeps the kids happy while their mother hangs out the laundry. The outbuildings have been removed or moved to other areas of the property. (Courtesy of the Chatham Historical Society.)

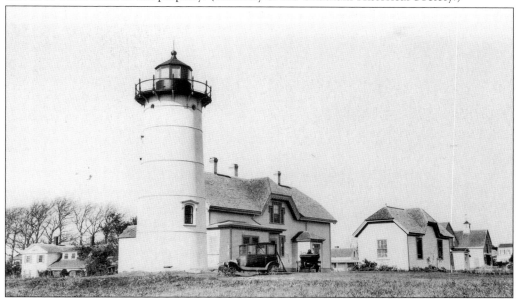

THE CHATHAM LIGHT. In 1923, the north tower of the twin towers in Chatham was torn down and taken to Eastham when the Three Sisters Lighthouses at Nauset had to be replaced. Since then, Chatham has had only a single light tower, but it flashes twice every 10 seconds in memory of its twin. This photograph was taken shortly after the north tower was removed. (Courtesy of the Chatham Historical Society.)

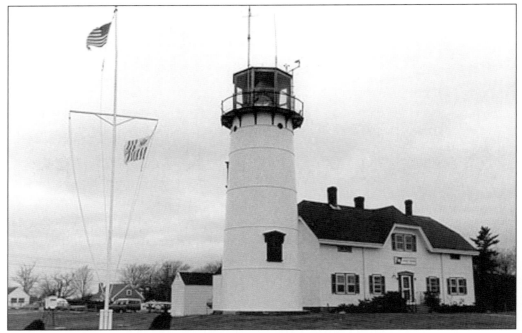

THE CHATHAM LIGHT'S NEW TURRET. In 1970, the Chatham Light turret was replaced. The light itself was automated in 1982 and, in 1993, a new directional circulating beam was installed. The old turret and Fresnel lens were donated to the Chatham Historical Society. The tower is 48 feet high. (Courtesy of the Chatham Historical Society.)

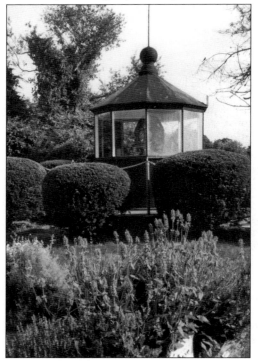

A LIGHTHOUSE MONUMENT. The turret from the Chatham Light, used from 1877 to 1970, now stands on the grounds of the Atwood House Museum. Donated by the U.S. Coast Guard, the monument honors the memory of Fannie Lewis Shattuck, who was born on July 10, 1873, and died on January 16, 1970. The herb garden in the forefront is maintained by the women of the Chatham Garden Club. (Courtesy of the Chatham Historical Society.)

Three
WRECKS AND RESCUES

One government tabulation has listed 500 wrecks off the Cape between 1843 and 1859; another gives 540 between 1880 and 1903. The greatest concentrations are around Provincetown and Monomoy, with no part of the outer shore spared from the grim record of catastrophe.

—Ernest John Knapton, *Chatham Since the American Revolution*

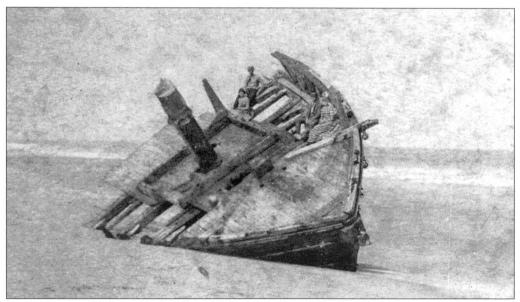

A NORTH BEACH WRECK. The shoals surrounding Chatham have broken hundreds of ships. During Josiah Harding's 28 years as lighthouse keeper, his diary records wrecks and collisions as commonplace, especially when the northeaster was aimed at Chatham's bluff. Once the survivors were saved, salvagers tended to the rest. Wreckers cut the mast off this derelict. Tourists found it a perfect perch. (Courtesy of the Nickerson Family Association.)

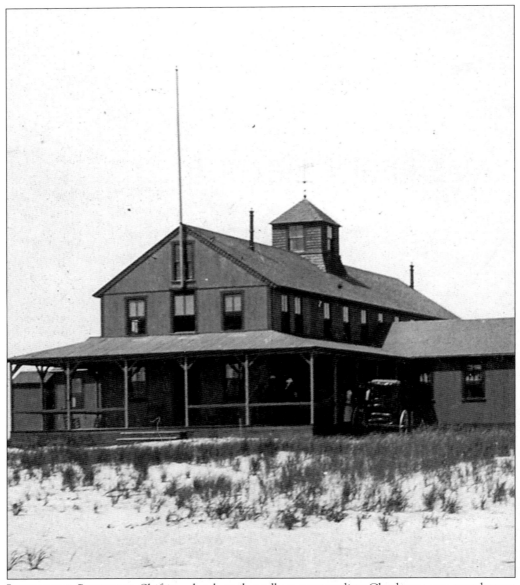

LIFESAVING STATIONS. Shifting shoals and sandbars surrounding Chatham were treacherous enemies of the sailing ships and cargo steams. The waters off Chatham have been described as a bad place in good weather and a dangerous place in bad weather. Hundreds of ships went aground and broke apart, and survivors found no one to help even if they made it to shore. In 1791, organized efforts came into being to create a rescue system. Huts were built along the coast by the Massachusetts Humane Society to provide temporary relief for shipwrecked sailors. Two huts were kept by Richard Sears in Chatham—one north of Chatham Harbor and the other halfway down Monomoy Island. In 1841, boats were purchased and local crews trained in Chatham. In 1871, Congress set up the U.S. Life-Saving Service. A year later, lifesaving stations were built at Chatham and Monomoy. Crews manned these stations 8 to 10 months of the year. The station is a good example of the structures built along the coastline. (Courtesy of the Nickerson Family Association.)

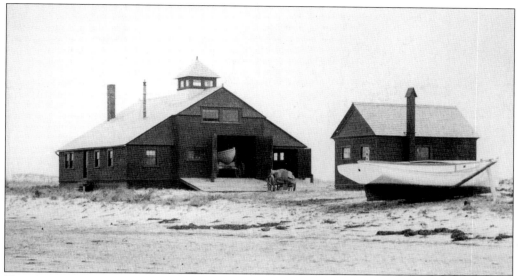

THE CHATHAM BEACH STATION. This is what the Chatham Beach lifesaving station looked like in 1891. Built in 1872, the station was kept busy. Here is a report from June 6, 1875: "The schooner Mary J. Yates of Boston bound from a fishing trip, struck the outer bars and was lost, total. Crew saved in dories." Lifesaving crews were most heroic, rescuing the shipwrecked. (Courtesy of the Chatham Historical Society.)

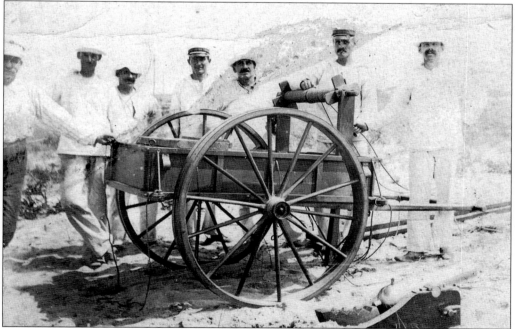

A LIFESAVING CREW. This crew of seven stands ready to shoot line from the throwing cannon in the right forefront of the photograph. The cart carries the line that will provide a lifeline from the shore to the ship in trouble. From this, a breeches buoy could be used to bring survivors to shore. In warm weather, the task was difficult and, in cold weather, it was daunting. (Courtesy of the Chatham Historical Society.)

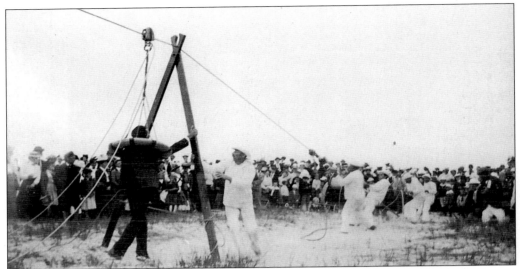

A Breeches Buoy Demonstration. The Chatham lifesaving station crew puts on a demonstration on how a breeches buoy works. Once a lifeline has been secured from the beach to the ship in trouble, a canvas sling is used to haul people from one ship to another or in rescue operations from ship to shore. Originally, the sling was in the form of a man's breeches. (Courtesy of the Chatham Historical Society.)

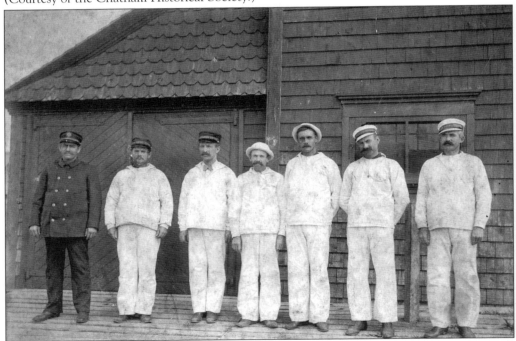

A Dangerous Profession. This lifesaving crew from Momomoy Station stands ready to risk their lives to save shipwrecked sailors and passengers. From left to right are station captain Seth Ellis, Walter Bloomer, Thomas Kane, Ed Studley, George Cahoon, Walter Wixon, and Richard Phillips. Ellis knew how dangerous lifesaving was. He was the sole survivor of the *Wadena* rescue (see facing page). (Courtesy of the Chatham Historical Society.)

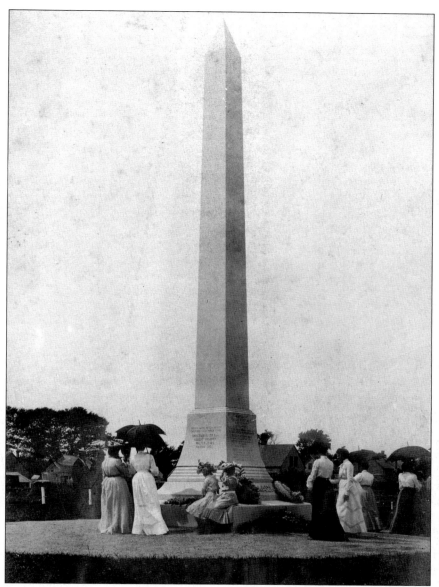

THE MACK MONUMENT. On March 16, 1902, weather conditions became more threatening, and all but five men were removed from the beached barge *Wadena*. Those remaining were barge owner William Henry Mack, Capt. Christian Olsen, Robert Malanox, Walter Zeved, and Manuel Enos. When the weather became worse, Monomoy Station captain Marshall Eldridge called for a full crew to set out for the men. As they were brought into the boat, a wave hit, filling it with water. A second wave hit harder, throwing all 13 men overboard. They held fast to the boat but, one by one, lost their grip. Some distance from the capsized boat aboard another stranded barge, Capt. Elmer F. Mayo of Chatham saw four men clinging to an overturned boat. Pitching a dory over the side, he rowed to the surfboat. Seth Ellis was the only man left. On shore, Francisco Bloomer saw Mayo rowing the boat through rough surf, ran into the water, and saved both men. In 1908, Mack's mother erected a memorial to her son near the Chatham Light. (Courtesy of Joseph Nickerson.)

THE OLD HARBOR LIFESAVING STATION. The first Old Harbor lifesaving station on North Beach was built in 1898. This photograph was taken in the late 1930s. Storms and wave action seriously compromised the station over the years and, in 1973, the National Park Service bought the building. It was removed by barge to Provincetown in 1977 to become a National Park Service museum. (Courtesy of the Chatham Historical Society.)

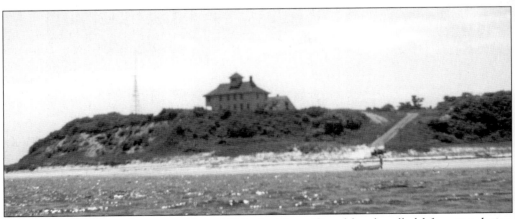

THE MORRIS ISLAND STATION. Since 1915, the Coast Guard has handled lifesaving duties. This Coast Guard station was on Morris Island, but all that remains today is a structure and pier visible from the Morris Island causeway. The station on the grounds of Chatham Light is the only Coast Guard facility in town. Its crews operate from the Fish Pier and Stage Harbor. (Courtesy of the Chatham Historical Society.)

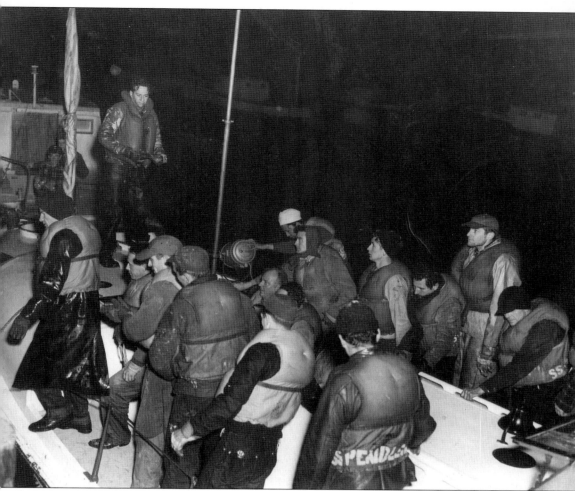

A GOLD MEDAL RESCUE. A northeaster rammed into Cape Cod on the night of February 18, 1952, followed by an SOS from the tanker *Fort Mercer*. Coast Guard cutters and lifeboats from Chatham and Nantucket rushed to its rescue, and then Chatham radar picked up another ship, the *Pendleton*, which was split in two. There were now two ships sinking. Bernard Webber, a boatswain's mate, and three crewmen set out in the motor lifeboat *CG36500*. As it was under way, the lifeboat lost its windshield. With snow almost blinding him, Webber said he had to "steer mostly by instinct." Tossing waters made the rescue difficult, yet only one man was lost. In Chatham, William Woodman from the Woods Hole station manned the radar, directing *CG36500* back home. How 36 men were able to survive in that small lifeboat is a wonder. In this view, Bernard Webber and crew help survivors as they land at the Fish Pier. The rescue made international headlines and earned the Coast Guard crew a gold medal for valor. (Courtesy of Fred H. Bearse.)

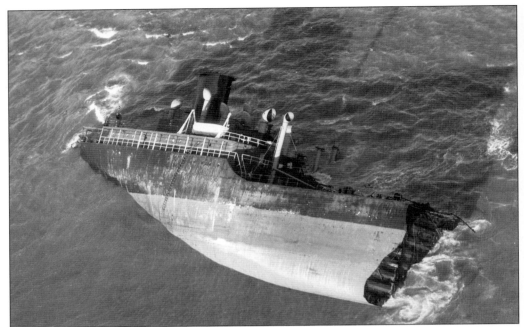

THE MORNING AFTER. The *Pendleton*'s stern is shown in this view with a rope ladder hanging over the side. Thirty-three men were on the stern when the *CG36500* arrived the night before. They scrambled down the ladder to safety. All but one was saved, despite ferocious seas and treacherous shoals. In August 1979, the wreck was declared a navigational hazard and was blown up by the Coast Guard. (Courtesy of Fred H. Bearse.)

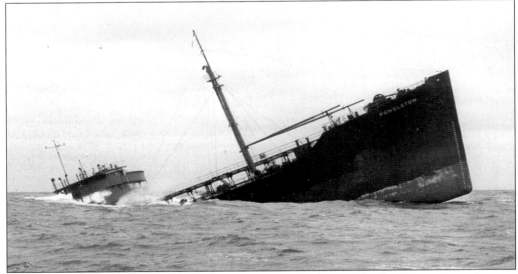

THE SINKING OF THE *PENDLETON*. This view shows the bow of the *Pendleton* as it sank seven miles east of Chatham. Nine men in all died, one during the *GF36500*'s rescue. The others, including the captain, were believed washed overboard during the ferocious winter storm. Local photographer Richard C. Kelsey took the photograph on page 33 and those on this page. (Courtesy of Fred H. Bearse.)

Four
LIFE IN CHATHAM'S VILLAGES

*West Chatham is different from North Chatham, the old Village isn't one bit
like Chathamport and South Chatham is an independent critter
that could be the 51st state. Each village has its own character.*

—Marcia J. Monbleau, *Home Song Chatham*

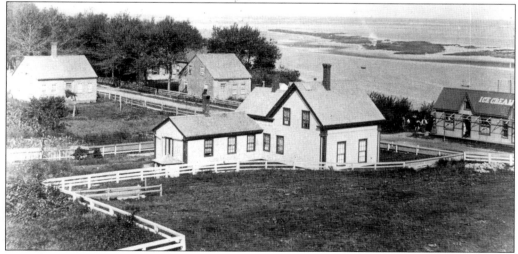

THE OLD VILLAGE. The hub of Chatham when the first settlers came was on high land just
west of Great Hill. A church, a graveyard, and a tavern were at its core. By 1870, the town
center had moved to the vicinity of the Chatham Light, now the Old Village. The Atlantic
Saloon was an ice-cream store run by Alfred Harding. It is now a private home north of the
overlook parking lot. (Courtesy of the Chatham Historical Society.)

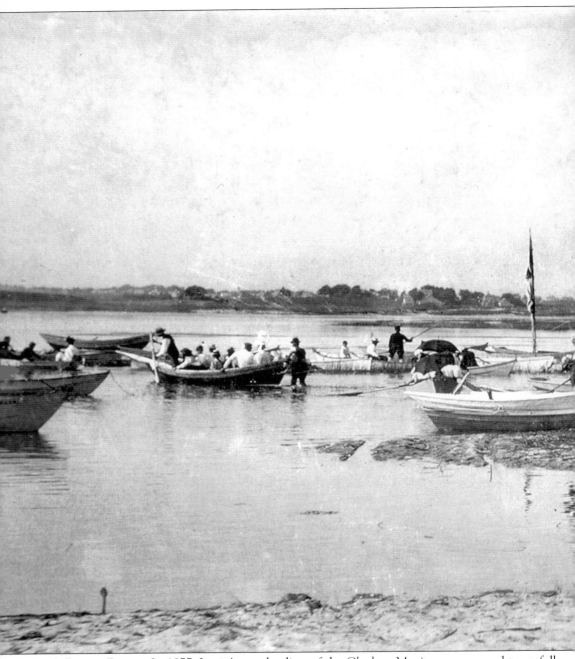

A BEACH PARTY. In 1877, Levi Atwood, editor of the *Chatham Monitor,* encouraged townsfolk to build cottages and inns for "those who would wish to spend a few weeks at the sea side." Not only did the locals build the cottages and open the inns, but many affluent visitors, some former inhabitants of Chatham, built their own homes. By the late 19th century, there was an established colony of "summer people" who came each year to Chatham. The beach party shown here illustrates why people flocked to this seaside town that was now a seaside resort. Women and children picnicked on the beach, while the gentlemen and boys spent their time boating. One of

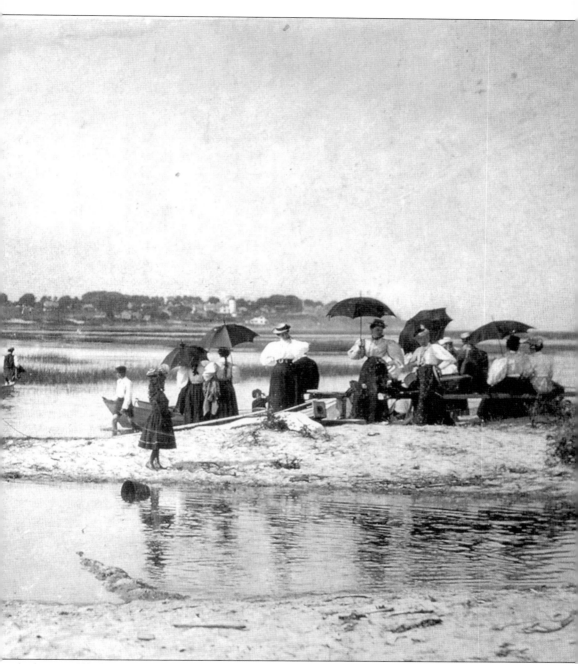

the boats is filled with young boys and girls on their way for a ride within the sheltered waters near the Chatham Light. The beauty of Chatham is timeless. Although the beach where these vacationers are is no longer there, the sunshine, the water, and the boating continue to attract visitors to Chatham. In the background on the right side of the photograph, one can just make out the Chatham Light. Vacationers and those with summer homes probably doubled the population, which was between 1,600 and 1,800 at this time. (Courtesy of Joseph Nickerson.)

THE HAWES GUESTHOUSE. In 1892, Selena and Zenas Hawes opened a boardinghouse for summer visitors in an 1815 home on East Main Street. "Chatham stands pre-eminent as a restorer of health," noted a local doctor, and many vacationers agreed. This picture was taken *c.* 1905. There were several other guesthouses at the time in Chatham. The Hawes home greeted visitors until 1970, when it closed to become a private home again. (Courtesy of the Chatham Historical Society.)

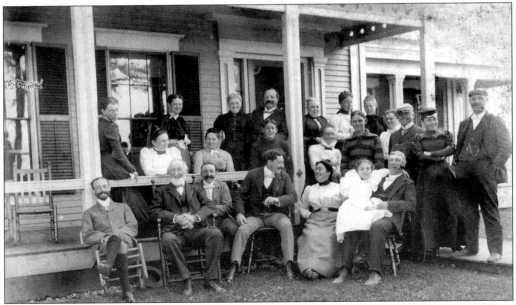

THE TRAVELERS' HOME. With the railroad bringing in more vacationers each summer, there was a great need for housing. The Travelers' Home was opened *c.* 1900 by Elijah Small, who had retired from a life at sea. In later years, the name was changed to the Monomoyick Inn. One of the oldest inns operating continually in Chatham, it was expanded and became the Cranberry Inn. (Courtesy of the Chatham Historical Society.)

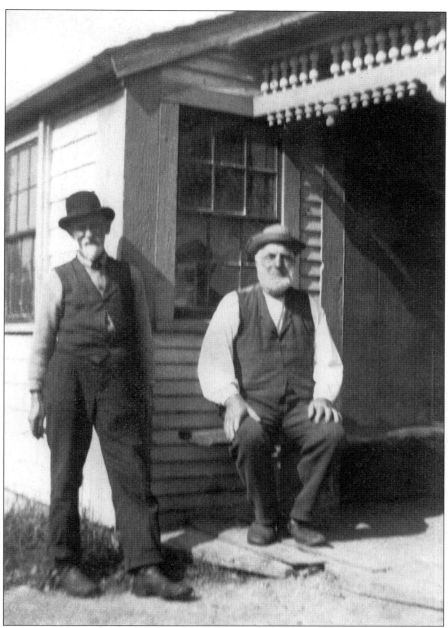

ANDREW HARDING'S STORE. On the same side of the street as the Chatham Light, just north of Wilderwood Lane on Main Street, Andrew Harding had a store that answered every need his neighbors might have had. It was the real center of the Old Village for many years. Andrew Harding died in 1919, but the store was kept open until the 1940s. Today, an oval sign identifies the small building, now a private home. Harding carried paints and oils, hooks and lines, tobacco and cigars, candy, and fruit in season. The shop was also a gathering place for the "old-timers" who regaled each other with stories, spun various yarns for listeners, and posed for many visitors' photographs. In this view, Andrew Harding is standing and Frank Tinkham is seated on the porch. (Courtesy of the Chatham Historical Society.)

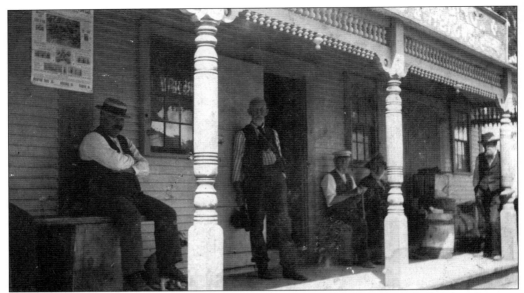

PORCH SITTING. Andrew Harding's store in the Old Village was a magnet for local men, many of whom had retired from life on and around the sea. This *c.* 1890 scene shows, from left to right, William Gould, Andrew Harding, Fernando Bearse, Frank Tinkham, and Seth Hammond on the front porch of the store. The men loved to spin tales for visitors and often posed for photographs. (Courtesy of the Chatham Historical Society.)

WATER STREET. This Old Village scene was photographed after 1883, when the telephone came to Chatham. On the left is the home of Mary Augusta Young. Her daughter Avis Chase later had a house called Porches at the end of Water Street. Both homes and another house there were left by Avis Chase to the Philadelphia YWCA, so its members could summer in Chatham. (Courtesy of the Chatham Historical Society.)

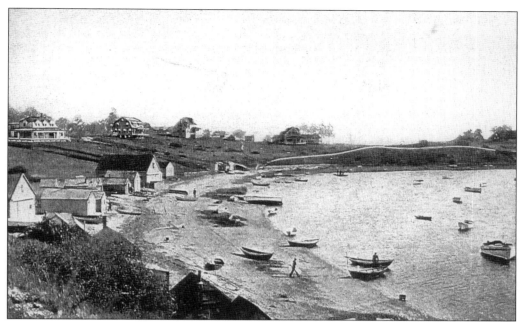

THE MILL POND. This early-20th-century view shows Avis Chase's home, Porches, on the far left. The other houses are located on School Street and Bridge Street. In the right foreground are fishing shacks and boathouses. Fisherman used this landing because of the access the Mill Pond had to Stage Harbor and beyond to Nantucket Sound. (Courtesy of the Chatham Historical Society.)

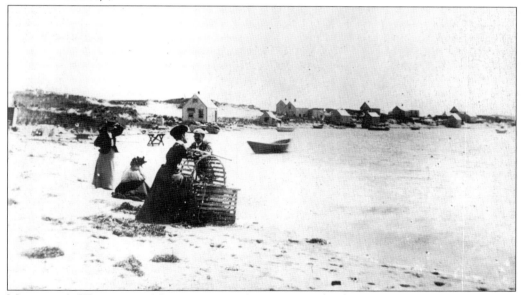

MONOMOY'S WHITEWASH VILLAGE. In 1895, Monomoy Island was a thriving community with its own village near the Powderhole, a lighthouse and lifesaving station, but the relentless winds, drifting sands, and ferocious storms pounded the life out of this barrier island. At one time, Monomoy was joined to the mainland, but that connection to Chatham has long since been broken. (Courtesy of the Chatham Historical Society.)

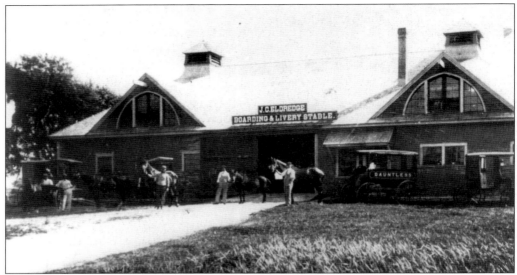

MAIN STREET, C. 1900. As tourism became more popular, the center of town moved from the Old Village farther west along Main Street. J.C. Eldredge's Boarding & Livery Stable was a mainstay. Since transportation was by horse and buggy, this was the "gas station" of its day. A full range of carriages is arrayed. (Courtesy of the Chatham Historical Society.)

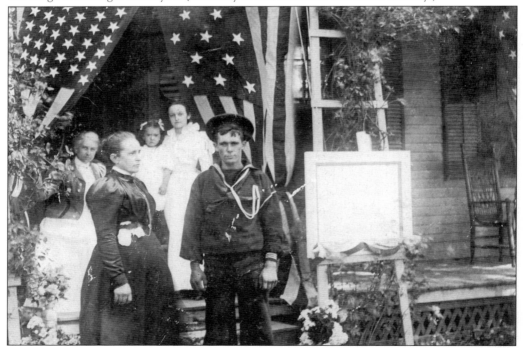

THE OCEAN HOUSE. It is 1898, and sailor Edward Kendrick Dean is celebrating his safe return from the Spanish-American War. The Ocean House, later the Wayside Inn on Main Street, is bedecked with old and new flags. Well-wishers welcome him home. The Wayside Inn and the Cranberry Inn are the two oldest continually operating inns in Chatham. (Courtesy of the Chatham Historical Society.)

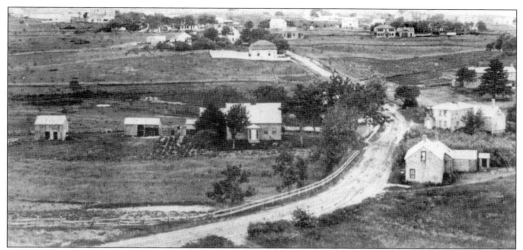

NORTH CHATHAM. A dusty Old Harbor Road leads to North Chatham, one of the earliest settled areas of Chatham. At one time, a deepwater harbor was located there. Several historic homes remain today. The house visible in the left foreground is still used as a private home. The Beehive, a home that is still standing, was used as a summer home by Pres. William Howard Taft's daughter. (Courtesy of the Chatham Historical Society.)

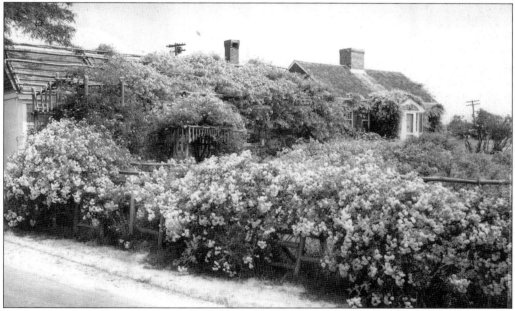

ROSE COTTAGE. This rose-covered Cape Cod cottage is actually an old house with a long history. Built c. 1821, the Capt. Samuel Davis home was purchased by Lillie and Sidney Stevens in 1916. The Stevenses planted the first pink rambler roses, which completely covered fences, the garage, and the homestead. They were a beautiful sight each summer, earning the home the Rose Cottage name. (Courtesy of the Chatham Historical Society.)

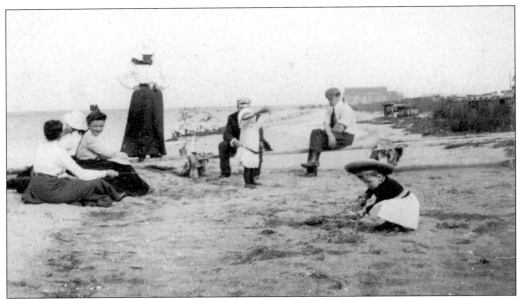

MINISTER'S POINT. This beach scene is probably in North Chatham at Scatteree Beach c. 1915. The women are involved in conversation as the men watch the two little boys—one displaying a piece of driftwood and the other digging in the sand. This bucolic scene was repeated along Chatham's shoreline as families sought relief from East Coast and Midwest cities. (Courtesy of the Chatham Historical Society.)

FISHER ELDREDGE'S FARM. In Chathamport, H. Fisher Eldredge built an estate where Harbor Coves is today. Shown with grandson Eldredge Shaw seated on a pony, he called this his farm. There were guesthouses, barns, chicken coops, and a dance hall. Less famous than his brother Marcellus, who endowed both the Methodist church and the town's library, Fisher was as wealthy. (Courtesy of the Chatham Historical Society.)

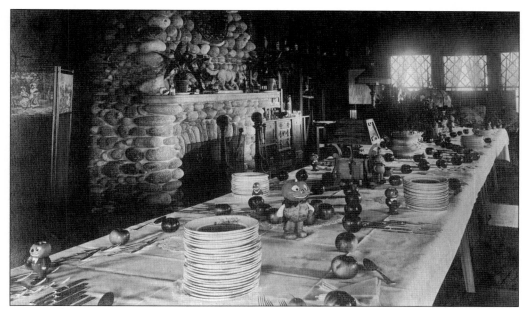

ELDREDGE-STYLE ENTERTAINING. Fisher Eldredge built his farm estate to house his children and grandchildren and to entertain friends lavishly. This elaborate table is set for a late-summer buffet. Martha Stewart would think the apples and pumpkin-men decorations are "a good thing." The setting is the dance hall, a separate building on the estate. An annual cornhusking party drew friends too. (Courtesy of the Chatham Historical Society.)

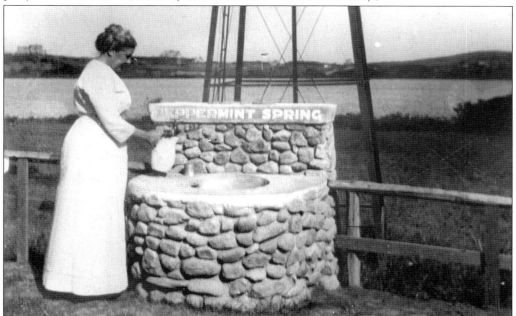

SAMPLING THE WATERS. Peppermint Spring is a freshwater spring off Old Comers Road in Chathamport, near Stillwater Pond. This woman is described on the back of the photograph as a relative of Evelyn Foster. Now surrounded by woods, Stillwater Pond then looked out on almost treeless hills. (Courtesy of the Chatham Historical Society.)

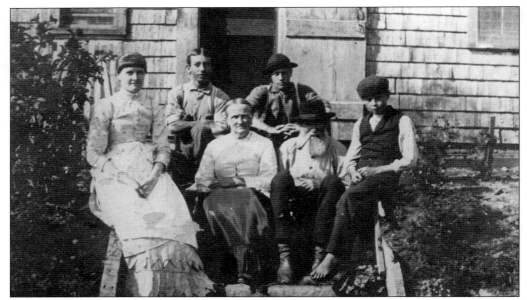

THE BASSETT HOMESTEAD. Nathaniel Bassett was one of Chatham's early settlers in what is now Chathamport, near the Harwich border. This photograph shows "Grandma and Grandpa" Bassett, possibly his descendants. Daughter Josephine is to the left of her parents. Obed (left) and Bartlett Bassett sit behind them on the steps of the homestead. The boy on the right is unidentified. (Courtesy of the Chatham Historical Society.)

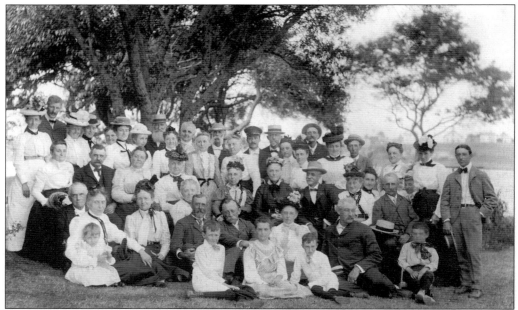

A TOWNSFOLK GET-TOGETHER. What occasion drew this group of well-dressed Chatham residents is unknown. They are on the south side of Oyster Pond. The Chatham Town Hall can be seen in the background just above the man on the far right. Since it burned down in 1919, this event could have something to do with the 1912 bicentennial celebration. (Courtesy of the Chatham Historical Society.)

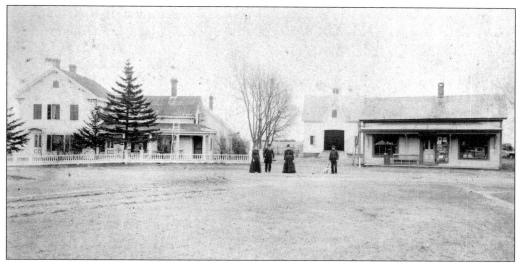

SOUTH CHATHAM CENTER. Levi Wilbur Delmar Eldridge built the house on the left c. 1840. In 1925, the barn in the rear was converted into a place to rent during the summer and then into a home for Cyrus Baker, Eldrige's grandson. After World War II, Cyrus Baker opened Baker's Hardware in the store shown on the right. All three structures are still there on Main Street. (Courtesy of Fred H. Bearse.)

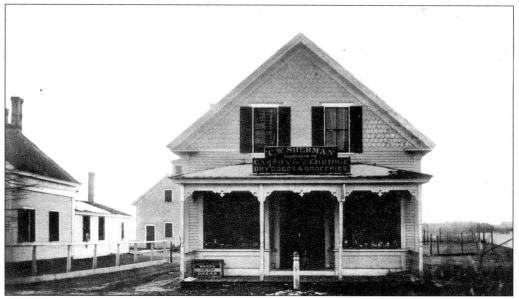

A SOUTH CHATHAM STORE. Cahoon and Eldridge Dry Goods & Groceries was the name of this South Chatham store. The Eldridge in this case was Levi's brother Hiram. On the far left, partially visible, is Capt. Frank Cahoon's house. The dry goods store now houses Pisces Restaurant, and Captain Cahoon's house is now the Nantucket House, a bed and breakfast. (Courtesy of Fred H. Bearse.)

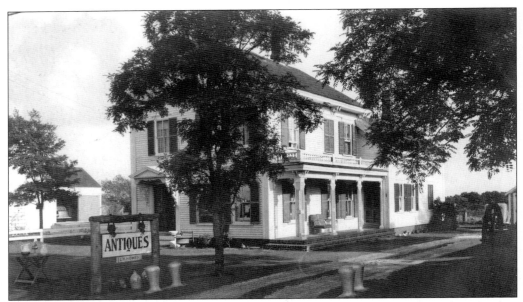

AN ANTIQUE SHOP. As people became interested in their past, antiques became hot commodities. Leslie and Huldah Howes in South Chatham recognized this and turned their antique home into an antique store. Many say that South Chatham is a lot more than five miles from downtown Chatham. It has a more country, casual feeling, but its people have roots that go way back. (Courtesy of Linda and George Goodspeed.)

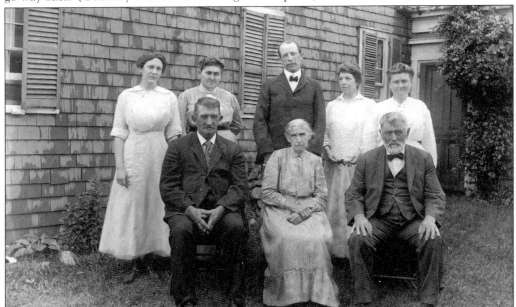

THE BEARSE FAMILY. The Bearses have lived in South Chatham since the early 1800s. Isaac and Bethiah Bearse brought up their children at the family homestead in South Chatham off Dusty Miller Road. Bethiah (seated, center) is pictured with family and friends *c.* 1910, including son Isaac Albert (seated, left) and his wife, Rosella (standing behind him). The couple lived here most of their married life. (Courtesy of Linda and George Goodspeed.)

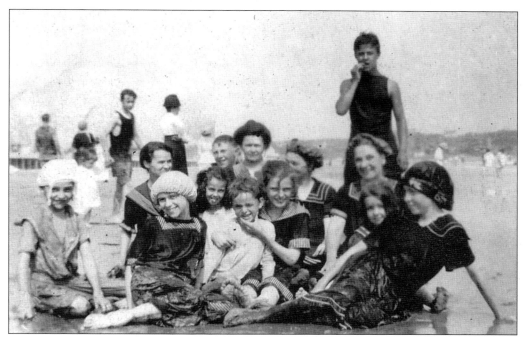

FOREST BEACH BATHERS. Forest Beach was reached by a dirt road, and the beach was about 200 feet wide when this *c.* 1910 photograph was taken. There were some bathhouses on the dunes. Check out the bathing caps and bathing dresses the girls are wearing. In the early 1900s, beach fashions were fashioned more for modesty than function. (Courtesy of Fred H. Bearse.)

BATHING BEAUTIES. Cape Cod was a conservative place (no doubt a throwback to its Puritan roots), so most towns had a chin-to-knees law for beach attire. In 1935, the *Boston Sunday Post* reported, "No longer need bathers, sun or ocean, beach strutters, or shore side paraders, fear the long arm of the law if they are not clothed from chin to knee." (Courtesy of the Chatham Historical Society.)

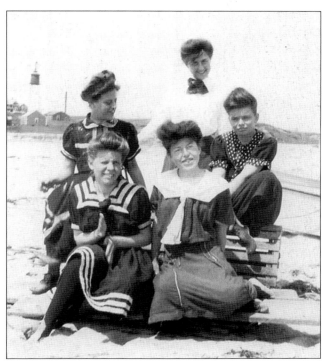

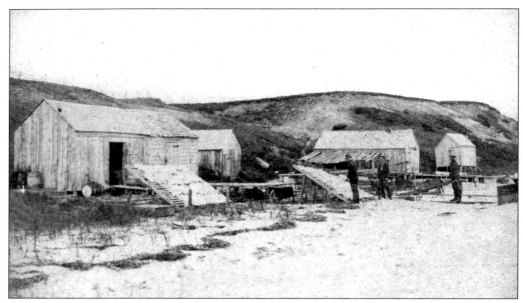

A NORTH CHATHAM SCENE. Fishermen stored their catch in shanties after they had been dried for distribution. Here, several fish flakes, or drying tables, can be seen in front of fish shanties on a North Chatham beach. There were no trees around, since they had been cut down for firewood and to allow grazing on the land. (Courtesy of Chatham Historical Society.)

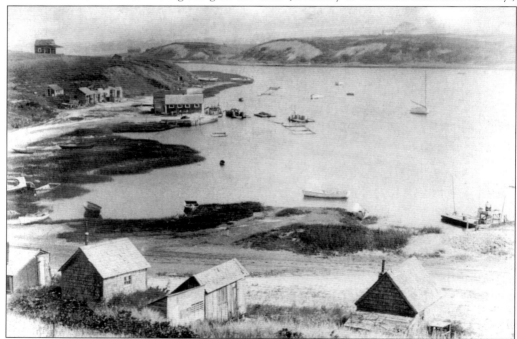

OYSTER SHANTIES. Oyster shanties in West Chatham dot the shore in this view looking toward Oyster Pond. Shellfishing was and continues to be an occupation of Chatham residents. While Oyster River and Oyster Pond are now primarily recreational areas, there are still remnants of the commercial businesses that thrived along the shore. (Courtesy of the Chatham Historical Society.)

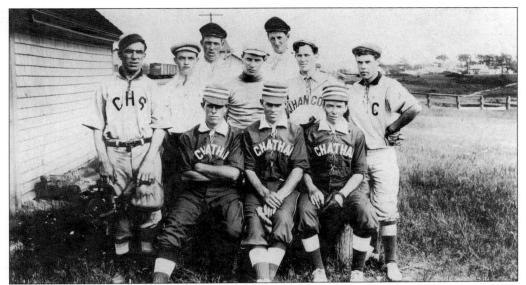

A Chatham Baseball Team. In 1908, when this photograph was taken, Chatham had already learned the allure of baseball. Chatham beat Harwich 2-1 on July 4, 1908. The winning team includes, from left to right, the following: (front row) Bernard Nickerson, Norman Jones, and Able Nickerson; (back row) Jack McKay, B. Kendrick, Harold Bassett, Dallas Smith, George Rogers, Ed Howes, and Theodore Bearse. Today, the Chatham A's draw crowds. (Courtesy of the Chatham Historical Society.)

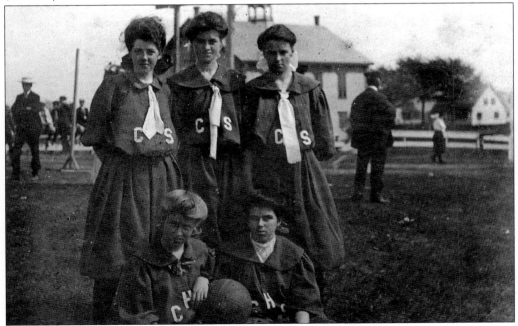

A 1908 Basketball Team. The Chatham High School girls' basketball team poses in the playground. That is the old town hall in the background. Pictured from left to right are the following: (front row) Doris Rogers and Viola Olson; (back row) Mary Bassett, Irene Eldredge, and Gertrude Johnson. (Courtesy of the Chatham Historical Society.)

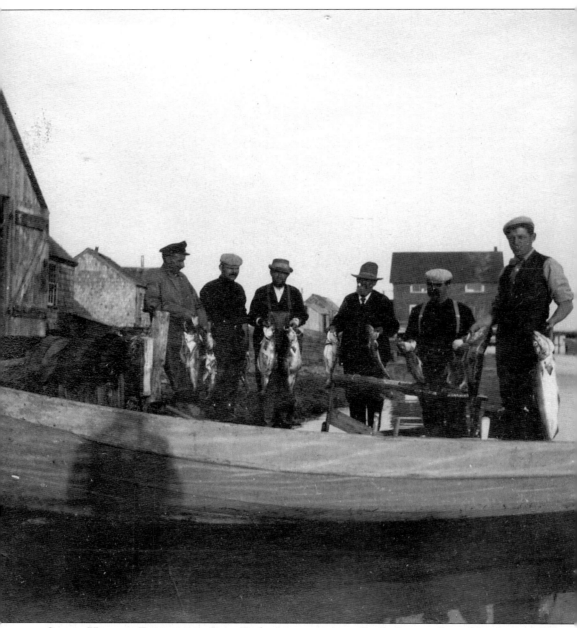

STAGE HARBOR FISHERMEN. Cape Cod owes its name to Bartholomew Gosnold, who in 1602 anchored offshore and took such a great store of codfish that he named the place for the fish. Fishing since then has been the focus of many men, including these fishermen displaying their catch in Stage Harbor *c.* 1908. (Courtesy of the Chatham Historical Society.)

Five

CHATHAM COMES OF AGE

This . . .view of Chatham gives small idea of its true extent, which embraces
luxurious hotels and country boarding houses, princely estates and cottages,
summer bazaars, beach clubs, windmills, golf links, and a transatlantic radio station.

—Samuel Chamberlain, *Cape Cod in the Sun*

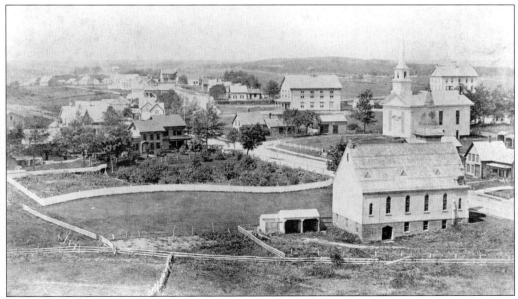

DOWNTOWN CHATHAM, C. 1890. The Universalist church, now St. Christopher's Episcopal
Church, is in the foreground, with the Congregationalist church behind it. To the right rear of
the Congregationalist church is the high school. To the left, farther along Main Street, is the
Chatham Town Hall, which burned down in 1919. The rotary had not yet been constructed,
and Old Harbor was a dirt road. (Courtesy of St. Christopher's Episcopal Church.)

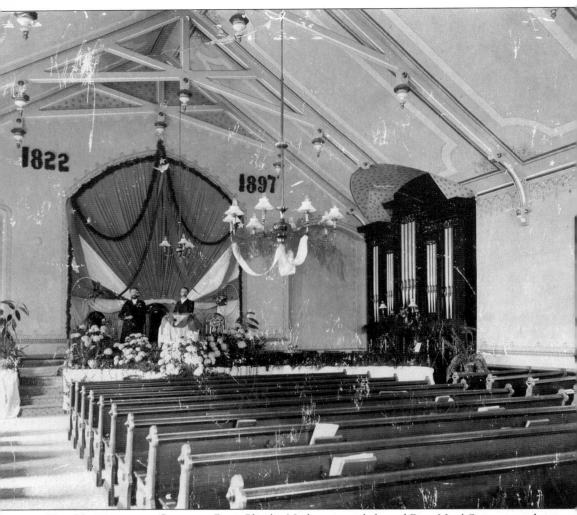

THE UNIVERSALIST CHURCH. Rev. Charles Nickerson, at left, and Rev. Noel Spicer preside at the Universalist church, decorated to commemorate its 75th anniversary. Organized in 1822, the society built its first church a year later. It was located on a site within the Universalist cemetery. A second and larger edifice was destroyed by fire in October 1878. Dedicated in November 1870, the church shown here became St. Christopher's Episcopal Church in the 1960s and was expanded. Two other churches were active in early Chatham. The first Congregational meetinghouse was built in the 1700s and, for many years, was the only church in town. The congregation moved to its present location on the rotary in 1866. Methodists have worshiped in Chatham since 1799. A church at Main and Cross Streets was constructed in 1849 and renovated in 1900. The Baptist church on Old Harbor Road became a Masonic temple. Holy Redeemer Catholic Church was built in the 1920s. Today, there are four other churches in town—Our Lady of Grace Church, the South Chatham Community Church, the Chatham Baptist Church, and a new Universalist Society. (Courtesy of St. Christopher's Episcopal Church.)

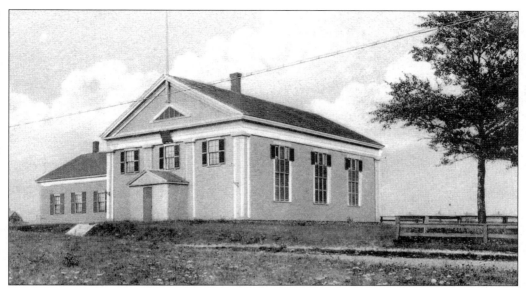

THE MASONIC TEMPLE. The temple for St. Martin's Lodge, Ancient Free & Accepted Masons, is located on Old Harbor Road in a building that was once a Baptist church. The first Baptist church in Chatham was built in 1827 near the Baptist cemetery. This church was later moved to Old Harbor Road and, when the Baptist society ceased to be, the church building was sold to the Masonic lodge. (Courtesy of Fred H. Bearse.)

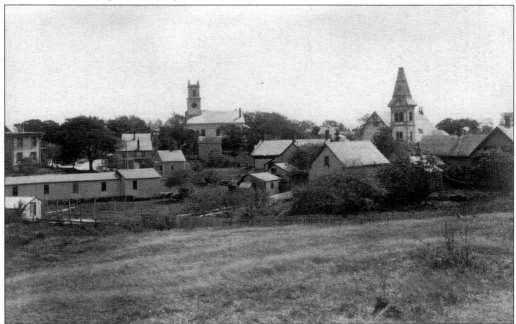

THE METHODIST CHURCH. The First United Methodist Church was formed in Chatham in 1799. A Methodist church was built near the Methodist cemetery in 1812. The present church (the square clock tower in the center) was built in 1849. A parish hall was added in the 1990s and is the site of lobster roll dinners on Fridays during the summer. The Universalist church steeple is to the right. (Courtesy of the Chatham Historical Society.)

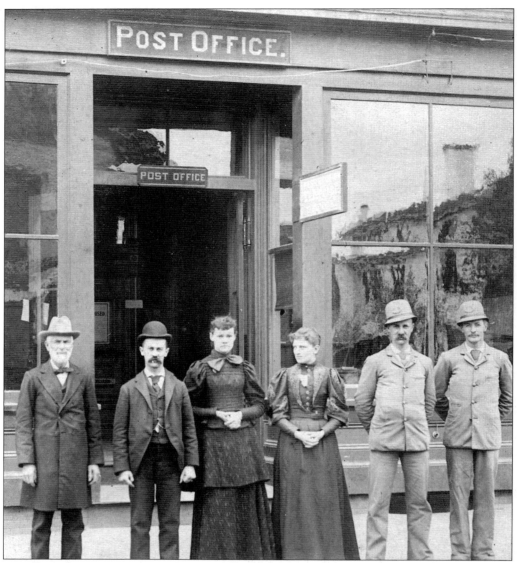

THE CHATHAM POST OFFICE. The first post office in the town was opened on January 1, 1798, with James Hedge as postmaster. Up until *c.* 1828, the post office was located in the northern part of town, near the old burying ground. At that time, a post office was established in North Chatham. The West Chatham post office was established in 1856. The Chathamport and South Chatham post offices were both established in 1862. Chatham's principal post office moved to Main Street *c.* 1893 or 1894, when this photograph was taken. The building was the two-story home of the post office and a barbershop upstairs. These unidentified men and women probably worked in the post office, and the two uniformed men were probably constables. The downtown post office moved about every three to five years. There are probably four more locations where it was located before the present building was constructed near the junction of Main Street and Crowell Road. (Courtesy of the Chatham Historical Society.)

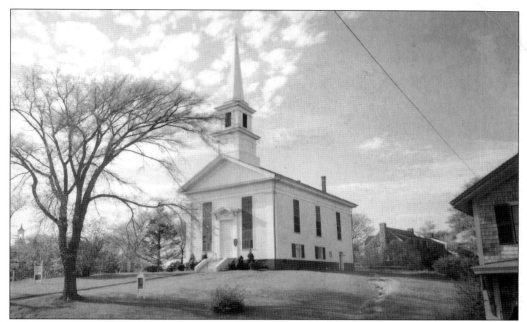

THE CONGREGATIONAL CHURCH. Up to 1851, the town meetinghouse was actually the Congregational church, since most townsfolk were members. A Congregational church was built shortly thereafter, but the building was dismantled in 1866. Its framing was used for the present church, which was larger than the first. It is located on the rotary where Main Street and Old Harbor Road meet. (Courtesy of the Chatham Historical Society.)

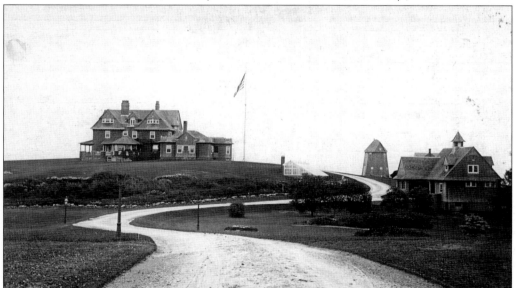

MARCELLUS ELDREDGE'S HOME. One of the most influential men in Chatham's history was Marcellus Eldredge. Although born in Chatham, he made his fortune as a brewer in New Hampshire. Watch Hill is the name of the magnificent home he built. Only its gates and a barn still remain. Eldredge endowed the local library and the Methodist church, and his beneficence is still felt today. (Courtesy of the Chatham Historical Society.)

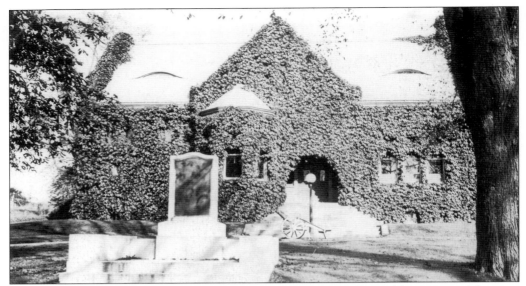

THE ELDREDGE LIBRARY. The ivy-covered building houses Chatham's library, a jewel for more than 100 years. On July 4, 1896, Chatham celebrated both the country's birthday and the dedication of its new public library on Main Street. Its architecture is a "modified Renaissance style, severe rather than ornate," according to the *Chatham Monitor*. It was presented to the town by Marcellus Eldredge, native son and wealthy industrialist. (Courtesy of the Chatham Historical Society.)

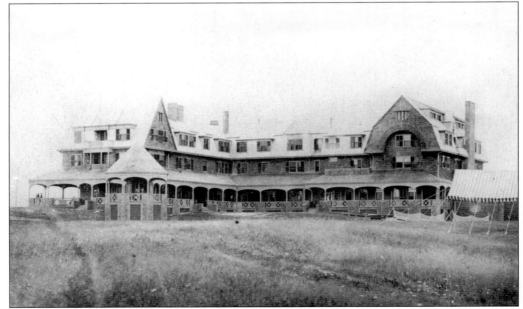

THE HOTEL CHATHAM. Construction began in October 1889, and the hotel opened on June 30, 1890. The three-story building featured gambrel roofs, a central tower at the front, and verandas around three sides. After just four seasons it was closed. The deaths of two of its owners—Eben Jordan in 1895 and Marcellus Eldredge in 1898—sealed its doom. It was demolished in 1907. (Courtesy of the Chatham Historical Society.)

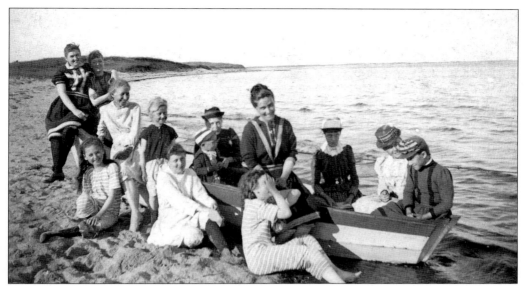

BOATING AND BATHING. The Hotel Chatham and the Hotel Mattasquason, both built by Marcellus Eldredge, prided themselves on wonderful seaside views. Both hotels advertised that the swimming (or bathing, as it was called then) was superb, and the hotels maintained a long line of bathhouses. The "salubrious climate" drew both young and old to Chatham's shores. (Courtesy of the Chatham Historical Society.)

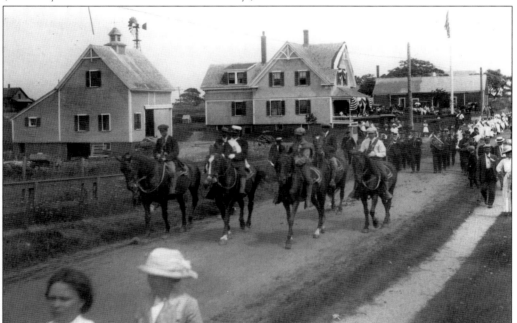

CHATHAM'S BICENTENNIAL. Opening ceremonies celebrating the 200th anniversary of Chatham's incorporation as a town began on August 1, 1912. The procession started at the railroad station and proceeded down Old Harbor Road toward Main Street. Chief Marshall A.A. Howard of the Stage Harbor Light and his staff of rough riders (deputy sheriffs) were first, followed by the Salem Cadet Band. (Courtesy of the Chatham Historical Society.)

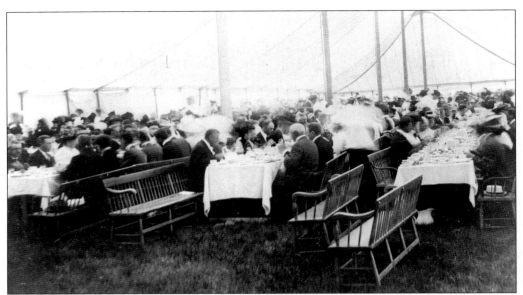

THE BICENTENNIAL LUNCHEON. A tent was erected on the Rockwell grounds, a grassy bluff above the Mill Pond. Two special tables were laid—one for the speakers and the other for the town elders. The menu consisted of cold roast turkey, cold boiled ham, cold boiled tongue, hot mashed potatoes, fresh vegetable salad, olives, pickles, rolls, butter, assorted creams and sherbets, frozen pudding, assorted cakes, and coffee. (Courtesy of the Chatham Historical Society.)

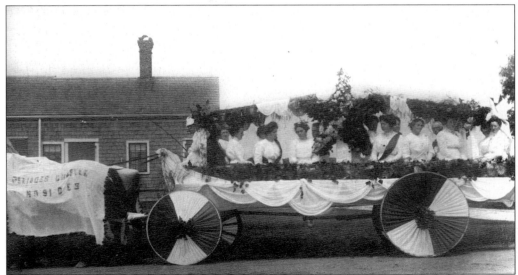

THE BICENTENNIAL PARADE. The official report states that the next day, the parade "marched down the main street of the village, counter-marched at the Eldredge stable . . . turning on itself . . . and then rolled triumphantly over to the Rockwell grounds for a ball game, dinner and the water sports in the afternoon." The Order of the Eastern Star float was given the first prize of $10. (Courtesy of the Chatham Historical Society.)

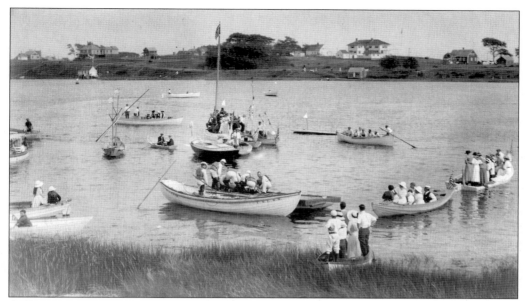

A LIFESAVING SERVICE DRILL. The keepers and crews of the Chatham and Monomoy lifesaving stations volunteered to present a drill during the bicentennial activities. Silas H. Harding, a Chatham native and a district superintendent of the service, had command of the crews. Keeper Hamilton and the Monomoy crew gave an exhibition of the boat drill on the Mill Pond. (Courtesy of the Chatham Historical Society.)

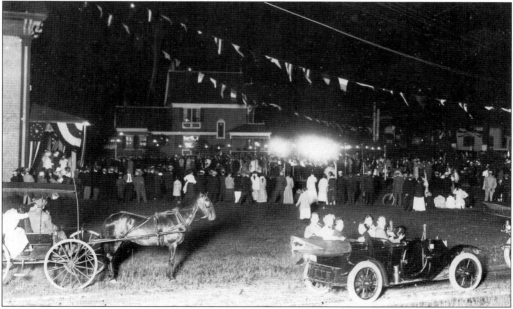

THE BICENTENNIAL CONCERT AND BALL. On August 2, 1912, a concert and ball took place in the decorated Chatham Town Hall (just visible on the far left). It was a most elaborate affair and drew more than 200 citizens and guests. Many wore costumes that when lit by electric lights made a most brilliant scene. The mode of transportation to the concert included horse and carriage, automobiles, and bicycles. (Courtesy of the Chatham Historical Society.)

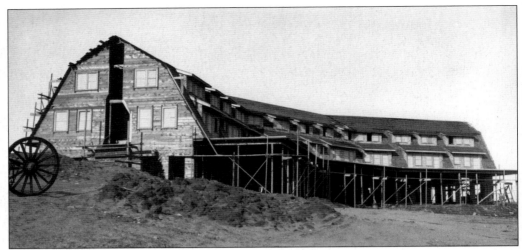

THE CHATHAM BARS INN. In 1913, the Chatham Bars Inn was under construction with its distinctive facade visible. It was built by Charles Ashley Hardy of Boston with views of Nauset Beach and the treacherous bars beyond. The hotel was designed to be self-contained with cottages surrounding it, as well as the rooms in the main building. (Courtesy of the Chatham Historical Society.)

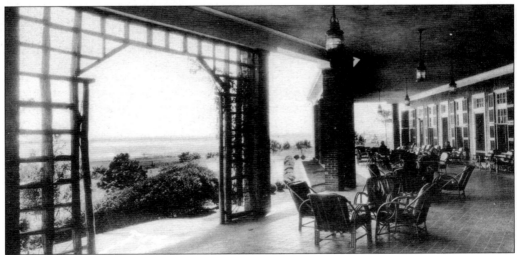

THE CHATHAM BARS INN SUN PORCH. The sun porch at the Chatham Bars Inn has a million-dollar view of Pleasant Bay and the bars beyond. Although the rattan furniture has changed with the times, the porch remains much the same today. Comfortable chairs and tables create a favorite spot for relaxing. Visitors to the world-class inn can enjoy the view, sip a drink, or even read a bestseller as the breezes keep them cool. (Courtesy of the Chatham Bars Inn.)

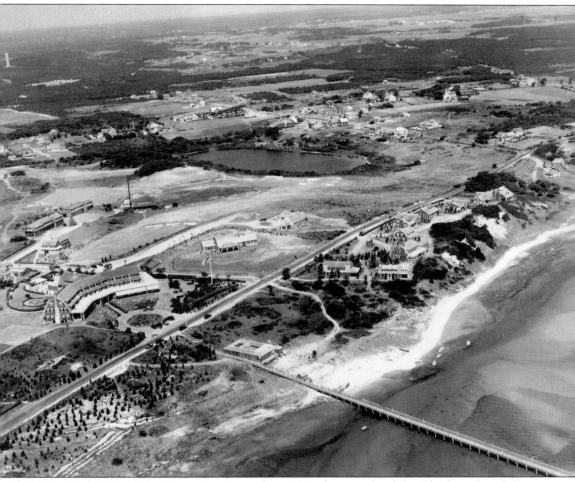

THE CHATHAM BARS INN FROM THE AIR. This 1920s photograph of the Chatham Bars Inn complex provides an excellent view of Shore Road and vicinity. Shore Road is the street that runs from lower left to almost the top right. The inn's pier, beach house, and several cottages are on the right side of Shore Road. On the other side and behind the inn is the nine-hole golf course, now the Chatham Seaside Links. When opened, the inn proudly advertised that both freshwater and saltwater showers were available. The Chatham Bars Inn opened as a full-service hotel. Tennis courts were added to the left of the beach house when that sport took on. (Courtesy of the Chatham Bars Inn.)

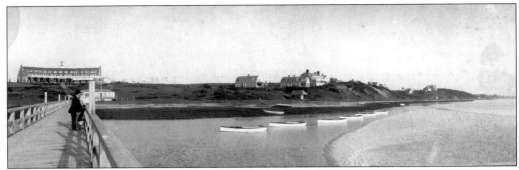

The Inn's Beachfront. A long pier was built soon after the Chatham Bars Inn was opened to allow bathers to walk to calm, shallow waters on the inside of the bar and to colder, deeper waters beyond the bar. A fleet of small sailboats (center) was available. The inn is visible in the left background. Several of the buildings visible in the distance remain in use today. (Courtesy of the Chatham Bars Inn.)

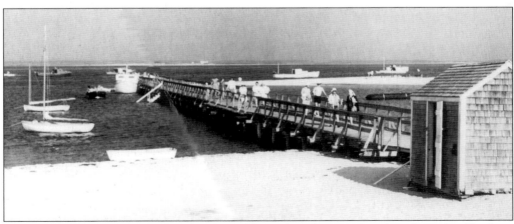

A Beach View. North Beach is barely visible in this photograph, taken from the Chatham Bars Inn's beach in the 1940s. The pier was then used mostly by guests to access pleasure boats or launches that ferried them to the barrier beach beyond. That is a sandbar to the right of the pier. (Courtesy of the Chatham Bars Inn.)

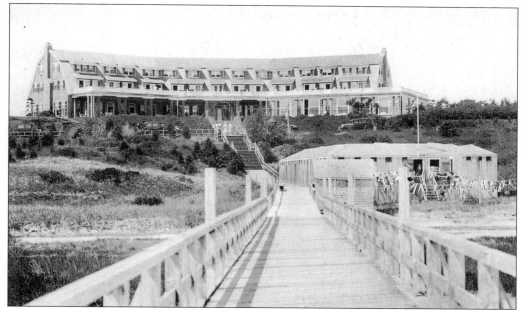

THE CHATHAM BARS INN BEACH HOUSE. This photograph of the beach house at the Chatham Bars Inn shows it to be primarily a changing place for bathers. Today, the beach house is located on the same spot, offering sunbathers a casual place for lunch. A pool and patio, plus a boathouse, are now located in this area. The pier is no more. (Courtesy of the Chatham Bars Inn.)

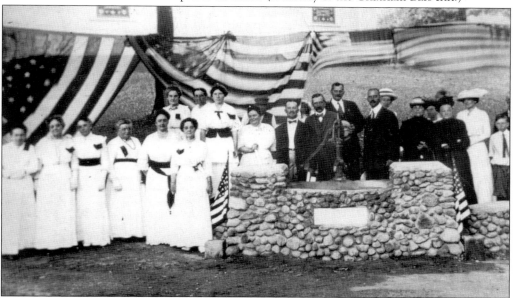

THE DEDICATION OF THE WATER TROUGH. Members of the Village Improvement Club and town dignitaries gather in front of the Methodist church to celebrate the dedication of the cobblestone water trough at Main and Cross Streets in 1914. Though not a working water pump any longer, the structure remains. Members of the Chatham Garden Club plant geraniums and other flowers as one of their townwide beautification projects. (Courtesy of the Chatham Historical Society.)

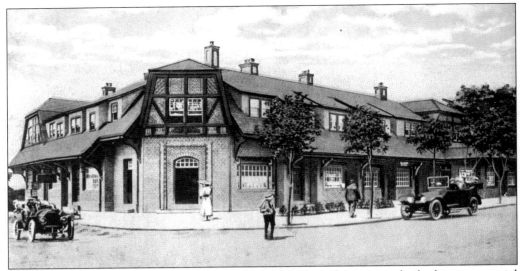

THE BRICK BLOCK. Boston stockbroker Charles Hardy and associates built this commercial building at Main Street and Chatham Bars Avenue. Finished in 1914, it has held a variety of businesses, including the post office. Quilty's, the shop of quality, occupied the east corner of the Brick Block for some years before it moved to the site of the present-day Chatham Squire. (Courtesy of the Chatham Historical Society.)

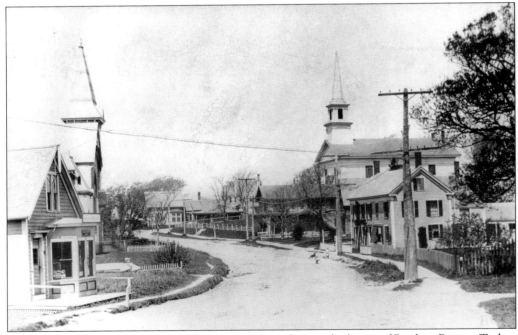

MAIN STREET, C. 1915. The first building on the right was the home of Reuben Bearse. Today, it houses Chatham Hardware. The home next door today houses a leather shop. On the left is the Universalist church spire, and on the right is the tower of the Congregational church. The small building in the left foreground was the office of Erastus Bearse and the Chatham Monitor newspaper. (Courtesy of the author's collection.)

A HIGH SCHOOL REUNION. In 1915, pupils of Professor Cross gathered at Rebecca Harding's home to celebrate the silver anniversary of the Chatham High School Association. From left to right are the following: (first row) Augustus Bearse, unidentified, Georgia Perry, Florence Linnell, and Will Harding's little girl; (second row) Rebecca Harding, Rhoda Atkins, two unidentified, Mary Gusta Young, three unidentified, Levi Smith, ? Jerauld, and Gus Hardy; (third row) Almena Nickerson, Mrs. Kingsbury Nickerson, Mrs. Joshua Gould, Mrs. Linnell, Arthur Crosby, Bertha Arey, Clarington Freeman, unidentified, Solomon Atwood, Charles Hardy, and two unidentified; (fourth row) Sam Harding, Ziba Nickerson, Hiram George, ? George, Mrs. James Hardy, unidentified, Marcus Howard, Ellen Perry, Almena Kent, Nat Kendrick, Georgie Bearse, Emma Crosby, Mrs. Seymour Nickerson, Seymour Nickerson, and Will Harding. (Courtesy of the Chatham Historical Society.)

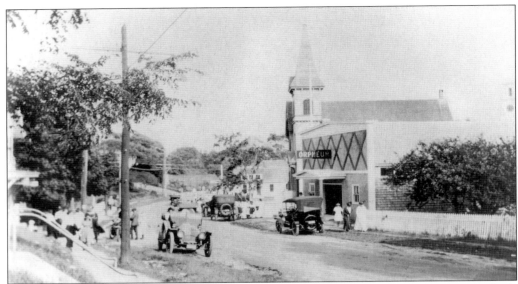

MAIN STREET, C. 1918. Hollywood had come to Chatham. The Orpheum Theatre was built in 1915 and operated as a motion picture theater and also as a performance stage for local theatricals. In 1930, the name was changed to the Chatham Theater. Today, the building houses a CVS drugstore. The spire belongs to the Universalist church, now St. Christopher's Episcopal Church. (Courtesy of the author's collection.)

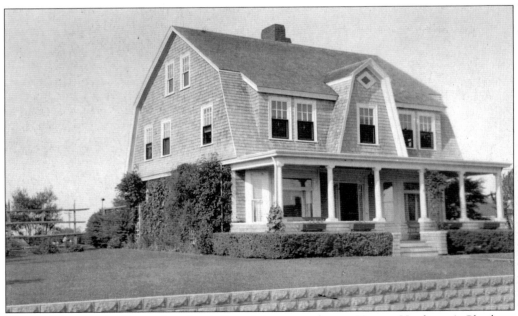

HEMAN HARDING'S HOME. Another influential man was lawyer Heman Harding. A Chatham selectman in 1899 and 1900, he became a state senator in later years. His home was on Main Street and, in most recent years, has housed one of Chatham's favorite restaurants and watering holes, Christian's. His wife, Edith, was a guiding force in women's clubs, locally and on the state level. (Courtesy of the Chatham Historical Society.)

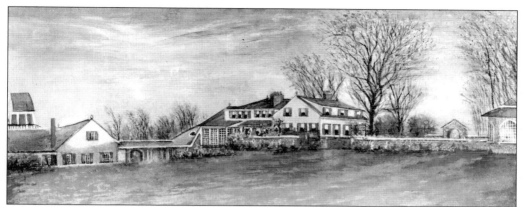

THE TOMLINSON ESTATE. This painting is of the North Chatham estate of the Tomlinsons. He was the president of National Biscuit Company. Today, the estate has been divided into two separate residences, and the connecting walkways and outbuildings are no more. The watchtower (far right) has been incorporated into one of the residences. However, the view of Pleasant Bay remains as breathtaking as always. (Courtesy of the Chatham Historical Society.)

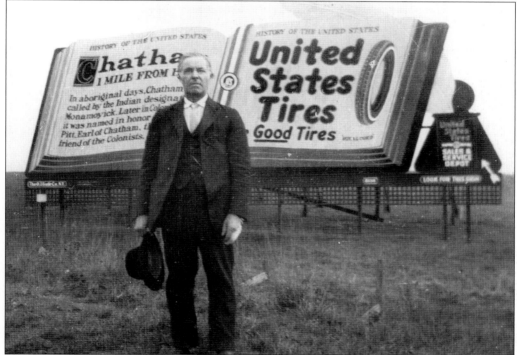

A WEST CHATHAM BILLBOARD. Albert Kendrick of West Chatham poses in front of an open-book-style billboard. Noting that Chatham was just one mile away, the left side of the billboard provided historical data, and the right provided an advertisement for tires. It was the automobile that opened the Cape to tourism. The sign was located where Route 28 meets the west end of Old Main Street. (Courtesy of the Chatham Historical Society.)

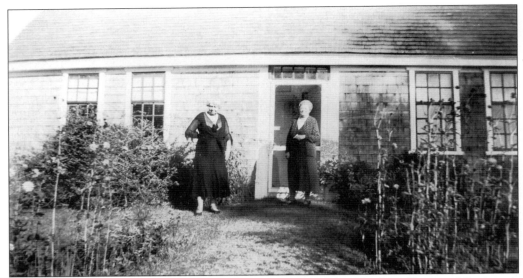

THE ATWOOD HOUSE MUSEUM. Alice Guild, president of the Chatham Historical Society, is shown on the left with a curator *c.* 1930. The Atwood House is the oldest house in Chatham, having been built in 1752. In April 1926, it was deeded to the Chatham Historical Society. The women of the society cleaned, painted, and wallpapered the front two rooms and entry, so that visitors could tour the home. (Courtesy of the Chatham Historical Society.)

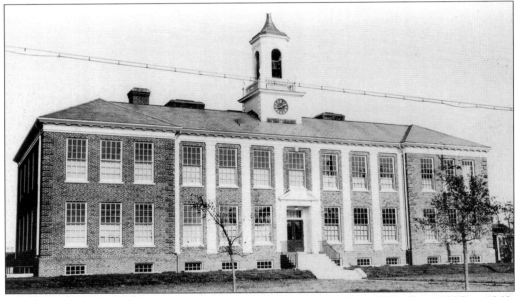

THE MAIN STREET SCHOOL. The Main Street School was built in 1924. From 1937 to 1963, 617 students spent all 12 years of school here. The 1850s school had been attached and, in the 1950s, other additions were made. In June 1998, the school officially closed with a reunion of former students. The school was once the focus for the community's education and, today, ideas are being advanced to make it a community center once more, with both young and old advancing the plan. (Courtesy of the Chatham Historical Society.)

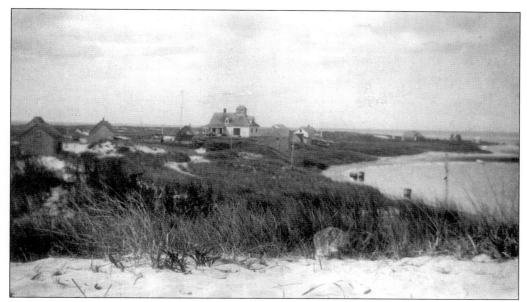

MONOMOY'S POWDER HOLE. This is the cove at the very tip of Monomoy. Whitewash Village thrived here in the 1850s. This 1930s scene shows the town has disappeared, but the U.S. Coast Guard Station (center) is surrounded by its outbuildings and private camps that were used for fishing, hunting, and just summer fun. The second house from the left is Dr. Neil and Esther MacDonald's camp. (Courtesy of Eileen MacDonald Moore.)

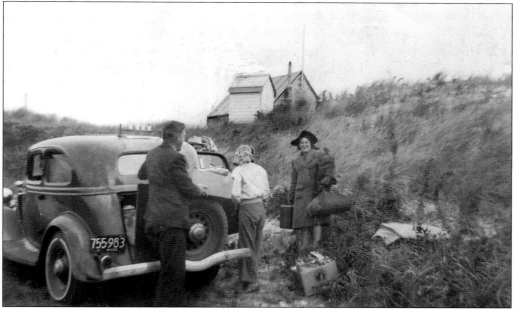

AT LAST. Dr. Neil MacDonald was a dentist from Arlington, Massachusetts. Dr. MacDonald, wife Esther, and daughter Dottie drove three and a half hours to the Eldredge Garage on Main Street, took air from the tires, and proceeded to their camp on Monomoy. The dirt road below the tennis club was the entry to Monomoy, which was attached to the mainland then. (Courtesy of Eileen MacDonald Moore.)

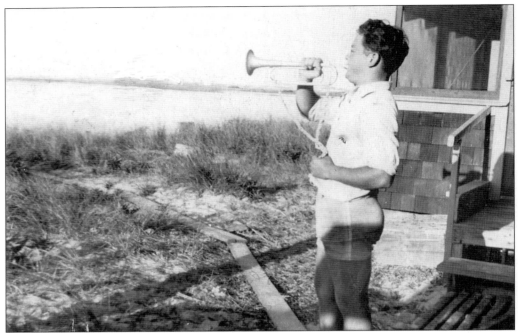

BLOWING TAPS ON MONOMOY. Quido Stello, whose family had a camp on Monomoy, blew taps during the summer at around eight each evening, when the Coast Guard crews took down their flag. Dottie MacDonald, higher up on the dunes, would echo his playing. Campers who had flags flying took them down at that time, too. (Courtesy of Eileen MacDonald Moore.)

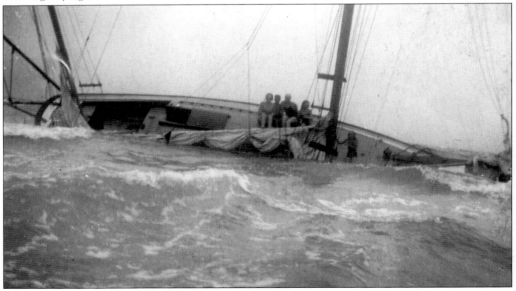

THE WRECK OF THE GADGET. Monomoy's treacherous waters confirmed their reputation in August 1938. The *Gadget*, a victim of Point Rip, went aground at Monomoy Point. Abandoned by her owners, the wreck became an attraction for the residents of the Powder Hole community. It was completed stripped of anything that could be carried off, including masts and engine. Everyone received some benefit from the salvage. (Courtesy of Eileen MacDonald Moore.)

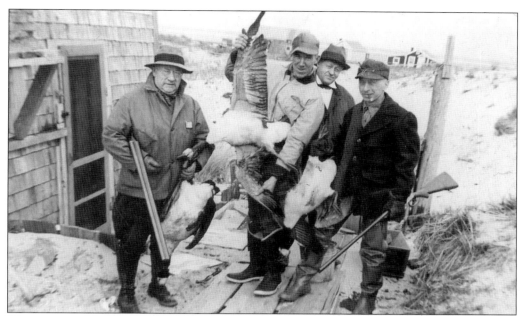

HUNTING ON MONOMOY. Dr. Neil MacDonald displays the wingspan of one of three geese this quartet bagged while hunting on Monomoy. The hunters include Dr. Crawford, Dr. MacDonald, Martin Daley, and Dan MacDonald. In the 1930s, the Canadian geese often remained on Monomoy during the winter. Other camps are visible in the background. Children who grew up summering on Monomoy recall this vanished community with great fondness. (Courtesy of Eileen MacDonald Moore.)

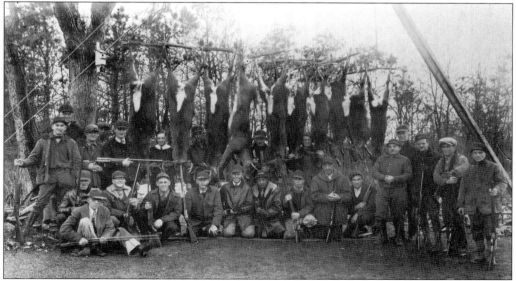

HUNTING AT HAWK'S NEST. Located in East Harwich and owned by T.W. Nickerson, Hawk's Nest was a hunting camp. This photograph was taken *c.* 1940 and shows T.W. Nickerson, standing on the far left with rifle in hand. Other hunters photographed include George Goodspeed, Ed Taylor, and Howard and Frank (Flute) James. In the background are 10 deer, which are great provisions for the winter. (Courtesy of Linda and George Goodspeed.)

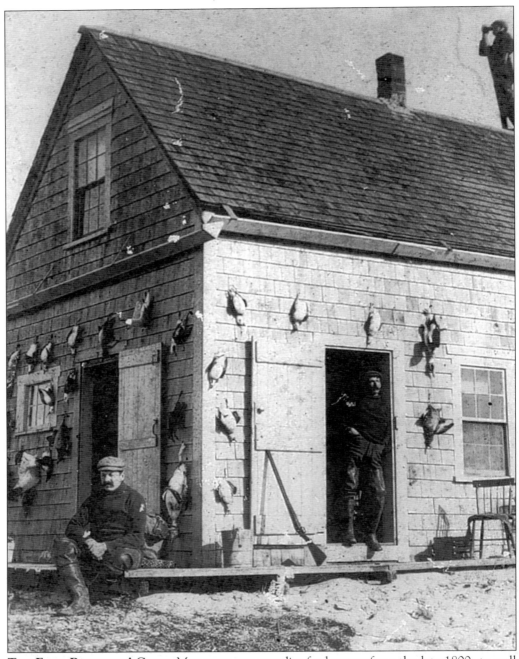

THE ELLIS BROTHERS' CAMP. Monomoy was paradise for hunters from the late 1800s to well into the 20th century. In 1862, the Brant Club was formed to hunt for birds on Monomoy. A brant is a small black-neck goose the size of a mallard. This photograph, taken in the early 20th century, shows the Ellis brothers at their hunting camp with some of their catch. On the roof is a spotter. (Courtesy of the Chatham Historical Society.)

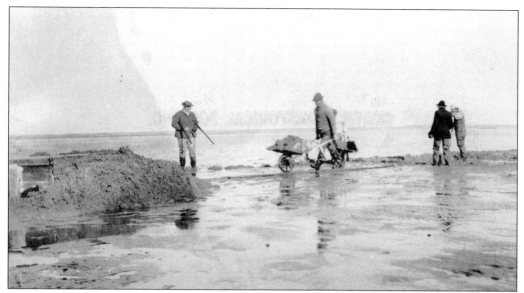

BUILDING THE BOX. Some duck hunters on Monomoy preferred shooting from boxes rather than from blinds. At low tide, a box was dug into the sand and reinforced with planks. More sand was brought to the scene by wheelbarrow to build up the bunker and prevent water from rushing in with the tide. This type of structure allowed the hunters to get very close to flocks of birds landing in the shallow waters. (Courtesy of the Chatham Historical Society.)

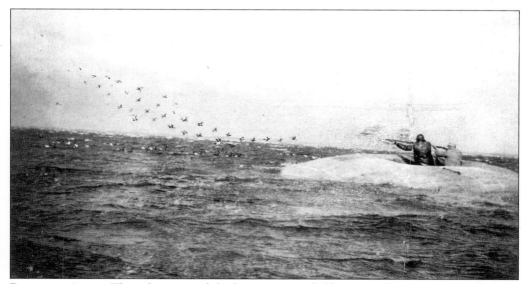

BLASTING AWAY. The tide is in, and the box is surrounded by water. Unsuspecting ducks have landed nearby and some are just taking flight. That is when the hunters rise from their bunker and fire away. Since a dog is not visible, it is anyone's guess how the kill was retrieved. (Courtesy of the Chatham Historical Society.)

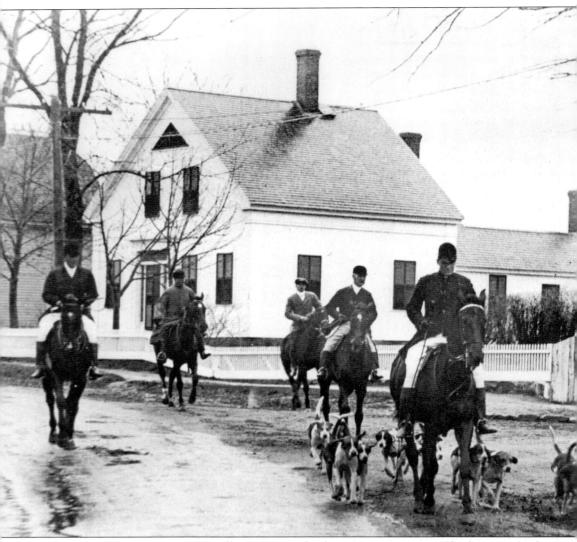

RIDING TO THE HOUNDS. "Tally Ho!" sounds along Main Street in Chatham as the hunt follows the hounds. Chatham is famous for its foxes, mostly those kits born near the Chatham Light Beach. It is unknown exactly when this photograph was taken, but it has to be before the house in the rear became Chatham's town hall in 1931. Prior to that, town offices had been in the Main Street School building. (Courtesy of the Chatham Historical Society.)

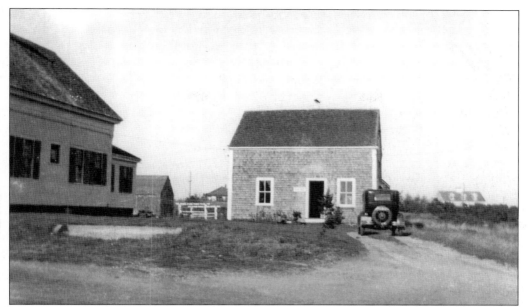

ACT ONE. This was the property that Mary Winslow (and before her, artist Harold Dunbar) thought had possibilities to be "a temple of the arts." Dunbar had made some attempts at using the building in 1934 and 1935 to no avail. In 1938, Mary Winslow bought and renovated the structure, which had been a toy factory. It became Chatham's Monomoy Theatre. (Courtesy of the Chatham Historical Society.)

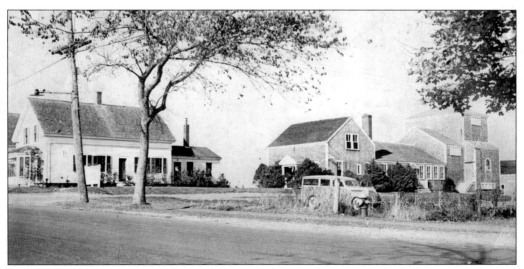

THE MONOMOY THEATRE. The first play in the theater opened on July 2, 1938, and was a comedy, *George and Margaret*. Tickets prices ranged from 55¢ to $1.93. Ohio University took over the theater. The Chatham Drama Guild, founded in 1932, often used the theater when Monomoy's season was over. The drama guild eventually built its own theater on Crowell Road. (Courtesy of the Chatham Historical Society.)

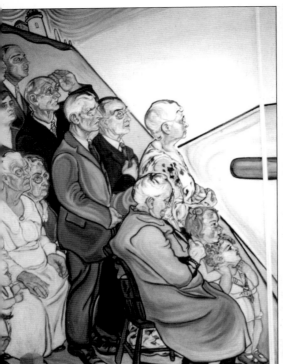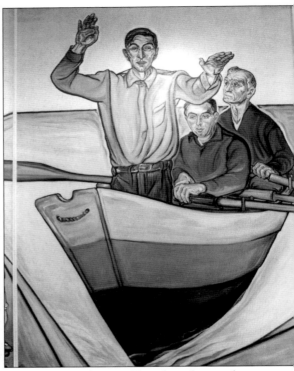

ALICE STALLKNECHT'S MURALS. Chatham was home to Alice Stallknecht, who was born on March 4, 1880, in New York City. She moved to Cape Cod in 1910 with her husband, who had suffered a breakdown. They settled in Chatham, where he fished, scalloped, and farmed their five acres of land. Stallknecht began to paint in 1929, and her first exhibit was in New York City in 1931. That same year, she painted a mural in three parts, *Christ Preaching to the Multitudes*. Christ was at its center, and listening to him on either sides was a faithful congregation. What was most striking about the mural was that Stallknecht's neighbors, people who attended the Congregational church primarily, were the very recognizable models for Christ and the multitudes.

While Alice Stallknecht never disclosed the person on whom Christ was modeled, after her death it was acknowledged that it was Sabin (Slim) Hutchings. When Stallknecht lent the murals to the Congregational church so they could be hung in the entryway, everyone pointed to the different figures and recognized who had been the model. The tremendous interest in the 9-by-20-foot piece of art provided the church with money from the entry fee charged to see it. "Alice Stallknecht captured a unique American experience and way of life," noted William C. Agee, who was the director of the Museum of Fine Arts in Houston. (Courtesy of the Chatham Historical Society.)

CHATHAM'S TREASURE. When the mural was removed from the church, Alice Stallknecht purchased a war surplus building from the Chatham Naval Air Station. After removal to her property, it housed *Christ Preaching to the Multitudes* and another mural, *The Circle Supper*, which she had painted in 1935. The latter she had lent and hung in the Congregational church's interior. Next, Stallknecht painted *Every Man to His Trade*. *Christ Preaching to the Multitudes* was exhibited in Los Angeles, Houston, and Washington, D.C., in 1977. The barn with all its murals was given to the Chatham Historical Society and was moved and annexed to the Atwood House Museum. (Courtesy of the Chatham Historical Society.)

THE WEIR FISHERMAN. This panel from *Every Man to His Trade* uses local resident George Crowell as the model. The panels (30 in all) were painted in 1945. "As a painter, Alice Stallknecht is a 'natural;' she puts things down on canvas with unhesitating directness, as if reality guided her brush," said Lloyd Goodrich, director of the Whitney Museum of American Art. (Courtesy of the Chatham Historical Society.)

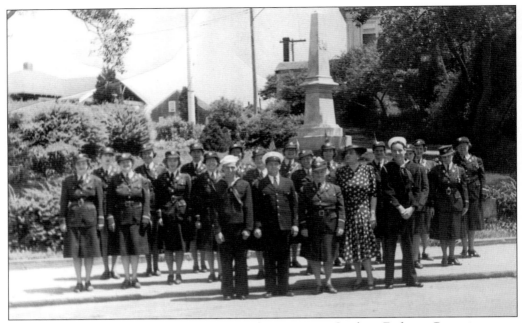

CHATHAM GOES TO WAR. Early in 1942, the Women's Civilian Defense Committee was formed by Edith Wheelwright and Mildred Jergensen. An air-raid warning center was opened, and women took two-hour watches at the center. The Chatham Chapter of the American Red Cross rolled bandages and knit sweaters. Marguerite Shaw, seen in the front row, opened a Victory Market on Main Street to raise money for war-related causes. (Courtesy of the Chatham Historical Society.)

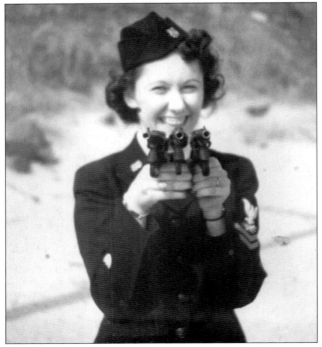

WOMEN AT WAR. The U.S. Navy took over the RCA station during the war, employing almost 100 Waves. Behind the lighthouse, the Coast Guard erected a new building for 14 Spars and a Loran station. Petty Officer Second Class Anita Freeman Eldridge worked on the Loran. While serving in Chatham, she met her husband, Sully, after he returned home from the war. (Courtesy of Anita Freeman Eldridge.)

Six

TRAINS, PLANES, BOATS, AND THINGS

Chatham had a long wait for its railroad station and regular service.
A wait of close to 25 years, almost a quarter century of waiting.

—Robert H. Farson, *Cape Cod Railroads*

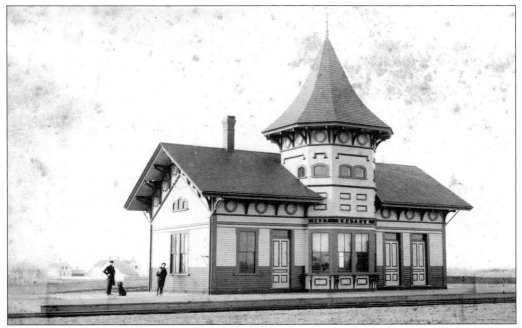

THE CHATHAM RAILROAD STATION. The railroad finally reached Chatham in November 1887. A depot, engine house, and turntable were built at Depot Road, another station in South Chatham, and a third in West Chatham to accommodate the new Hotel Chatham. Before the new branch line was built, people coming to Chatham disembarked in Harwich and had to take a stagecoach into town. (Courtesy of the Chatham Historical Society.)

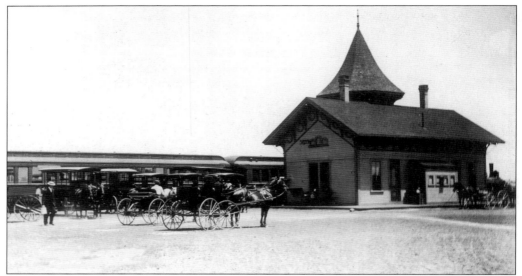

PASSENGER TRAVEL. Cars on the Harwich-to-Chatham run were lit by kerosene lamps, instead of gas. They were not as fancy as some used by the Old Colony Railroad. Each car contained a small coal stove in the corner. To keep warm, you had to be near it. The fare from Harwich to South Chatham was 20¢, and from Harwich to Chatham was 35¢. (Courtesy of the Chatham Historical Society.)

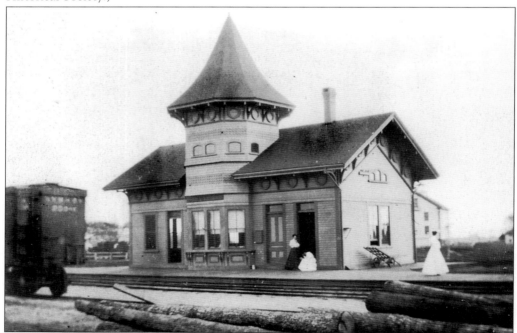

MOVING FREIGHT. Freight from Harwich to Chatham was 5¢ per 500 pounds. The first carload of freight out of Chatham was cranberries on their way to A. Ryder and Company in Chicago. The former Harwich-to-Chatham stagecoach drivers now became local express cart drivers and picked up and delivered shipments. The railroad put the packet boats out of business. (Courtesy of the Chatham Historical Society.)

THE SOUTH CHATHAM STATION. The South Chatham railroad station was located at Meetinghouse Road and Route 28. Until service was discontinued in 1937, students rode the train to the Main Street School from both the South Chatham and West Chatham stations. The Chatham line was busy and prosperous until it was shut down in 1937. (Courtesy of the Chatham Historical Society.)

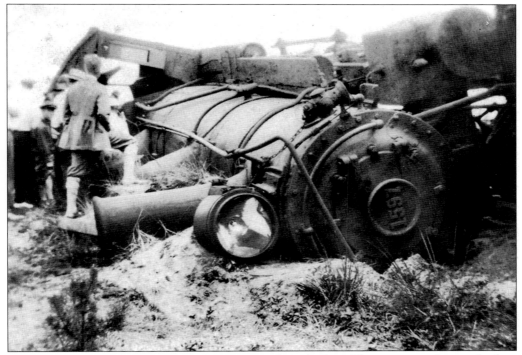

TRAIN WRECKS. A few serious accidents occurred on the line. The worst accident took place on August 31, 1921. The Chatham line had just one track and, for some reason, the locomotive was running in reverse. Just north of Queen Anne Road between West Chatham and Chatham, the tender jumped the track, separated from the locomotive, and flipped over. The locomotive crew was killed. (Courtesy of the Chatham Historical Society.)

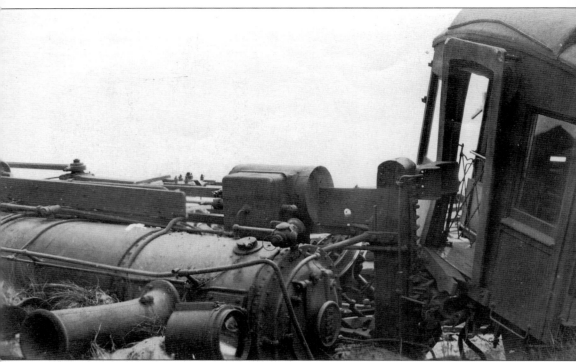

THE 1921 CHATHAM WRECK. Neither passengers nor the conductor, George Snow, were injured in the August 31, 1921 wreck. This photograph clearly shows the front of the locomotive resting against the first passenger car. That car lost its front wheels but did not overturn. The engineer, William Drew, and the fireman, William McKenna, were both killed in the disaster. In the crushed cab of locomotive No. 1597, built at the New Haven Railroad's Roxbury Shops in 1899, the throttle was off and the air-brake lever turned for brakes on. The passengers, the mail, express, and baggage were taken to Chatham in automobiles. When the New Haven Railroad, which leased the Old Colony line in 1893, discontinued service to Chatham, the town lost its $31,000 investment in the branch line. (Courtesy of the Chatham Historical Society.)

THE MARINE OBSERVATORY. Ziba Nickerson's home on Main Street and Mill Pond Road was the site of the Chatham Marine Observatory. The tower, which was destroyed by a hurricane in 1944, was a watch post used to see incoming ships. Since the building was also the site of a telegraph station, observers would notify owners of ships that they had been sighted incoming at Chatham. (Courtesy of the Chatham Historical Society.)

THE COMMUNICATIONS CENTER. That is what Ziba Nickerson's home would be called in today's jargon. Note the telescope in the right-hand tower window. Sightings from the tower were telegraphed to Boston. The telegraph was installed in 1855. When the telephone came to Chatham in 1883, the first switchboard was placed in Nickerson's home. (Courtesy of the Chatham Historical Society.)

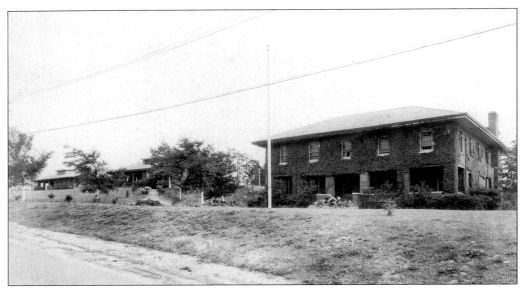

THE MARCONI WIRELESS STATION. When the first Cape Cod wireless communication station built by the Marconi Wireless and Telegraph Company was about to be lost through erosion, Chatham replaced it. It overlooked Ryder's Cove in Chathamport, well sheltered from the treacherous ocean. Located at the elbow of Cape Cod, there was no danger of interference from mainland transmission signals. Fifteen buildings were constructed in 1914. (Courtesy of Frank Hutchings.)

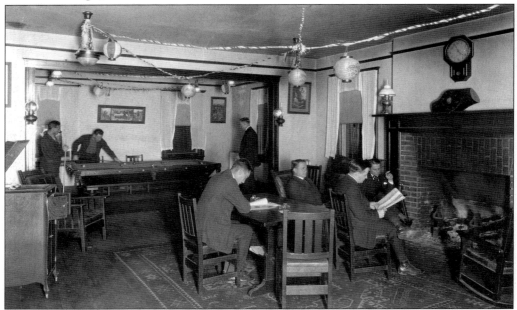

THE HOTEL. The largest brick building was a dormitory for single employees. This photograph shows the ground-level living area, complete with fireplace, pool table, and a phonograph. One operator noted that working at RCA's Chatham station was a job you had to like. The teletypes, typewriters, and telegraph keys were noisy, and there was often a haze of cigarette and pipe smoke in the air. (Courtesy of Frank Hutchings.)

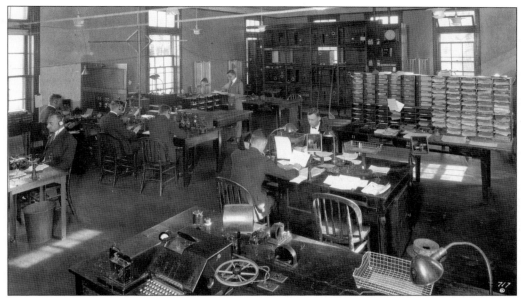

CALL LETTERS WCC. For almost eight decades, Wireless Cape Cod, WCC, and Chatham's call letters were among the most familiar to shipboard radio operators and hobbyists throughout the world. The Marconi station was taken over by the government in World War I and never returned. The operation was purchased by a consortium and, in 1921, RCA Communications took over. (Courtesy of Frank Hutchings.)

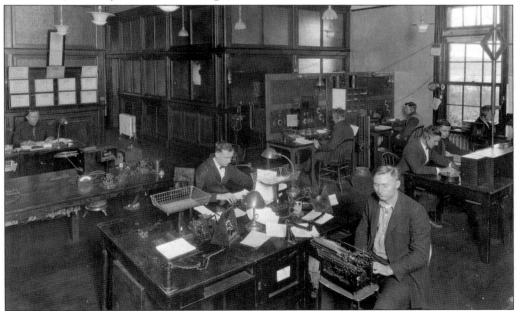

THE INFORMATION CENTER. This room was the nerve center of the station. At right rear, wireless radio operators listened for Morse code signals from Europe and ship to shore. WCC broadcast and received Morse code and telex messages from the cluster of brick buildings located on Route 28 around Old Comers Road. In the foreground, operators wait for messages to send. (Courtesy of Frank Hutchings.)

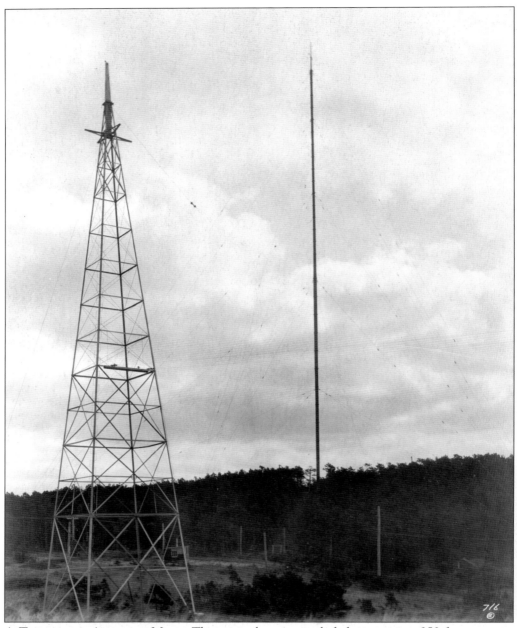

A TOWER AND ANTENNA MAST. The original station included six massive, 350-foot antenna masts that were located for six miles to the west on a direct line to Potsdam, Germany. Large transmission towers were also located throughout the Chathamport site and the South Chatham transmitting facility. Most of the antenna masts were dismantled in late 1919 and shipped to other marine radio stations in New Jersey. The largest, located at the station compound, towered 365 feet (447 feet above sea level). It was a landmark for local fisherman and boaters and was printed on charts until it was removed in 1954. Its flashing beacon was visible for 40 miles. (Courtesy of Frank Hutchings.)

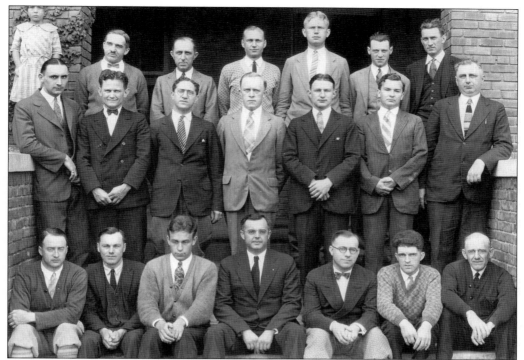

RCA's Chatham Staff. This photograph was taken *c.* 1923. Fred Heiser, who headed up the operation, is seated in the center of the front row. Sabin (Slim) Hutchings, who was in charge of the power station, is standing on the far right in the back row. The jobs were definitely white-collar ones, but there is a casual air here, with sweaters favored by some. (Courtesy of Frank Hutchings.)

A Station Manager's Residence. Houses were provided for married employees. Pictured *c.* 1923 is the home of Fred Heiser. Visible behind the house is the antenna mast that was not removed until 1954. This image provides a good idea of the comfort in which the RCA employees lived, but there was little else in Chathamport at that time, except for a few houses and the radio station. (Courtesy of Frank Hutchings.)

A POWER PLANT. The stovepipe has been removed, but the building at the northeast corner of Route 28 and Ryder Cove Road looks the same today. MCI sold both the South Chatham and Chathamport facilities to the town in 2000. All the buildings and towers have been removed from the South Chatham site, but the long-range future of the Chathamport complex is uncertain. (Courtesy of Frank Hutchings.)

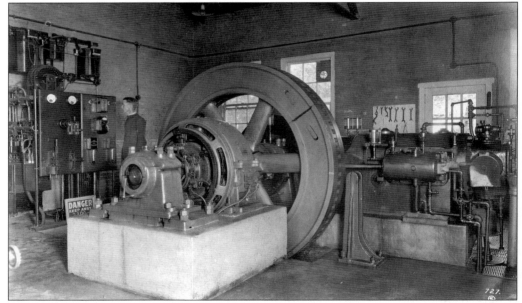

A GIANT TURBINE. Between 1920 and 1930, traffic increased dramatically. A stable source of power was necessary, and this turbine in the power plant did the trick. During World War II, the military took over the facility again. Only military personnel were employed at that time because of the sensitive nature of the communications intercepted from German boats and submarines. (Courtesy of Frank Hutchings.)

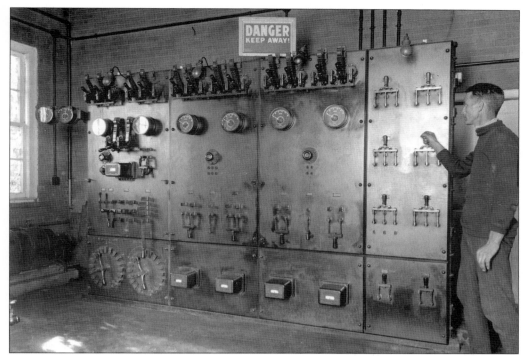

PULLING THE SWITCH. Sabin (Slim) Hutchings, who was in charge of the power plant at the RCA Communication's Chatham station, worked there for about two years. He left to start his own business, a gas station in town. In later years, he was elected a selectman. Hutchings is also reported to have been Alice Stalknecht's model for Christ in her murals for the Congregational church. (Courtesy of Frank Hutchings.)

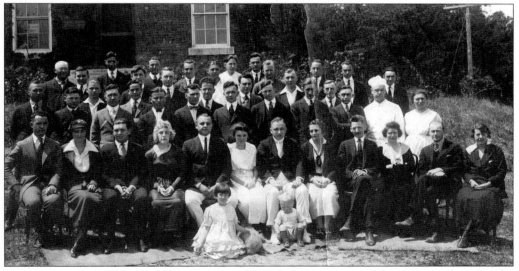

FAMILY DAY AT WCC. Fred Heiser managed WCC for many years. This seems to be a family-oriented event at the station. Mr. and Mrs. Fred Heiser, fourth and fifth from the left, are in the front row next to their daughter Arlene Heiser Foster and Leslie and Madge Strong. Heiser's younger daughter, Irene, is seated in front of her father. (Courtesy of Linda and George Goodspeed.)

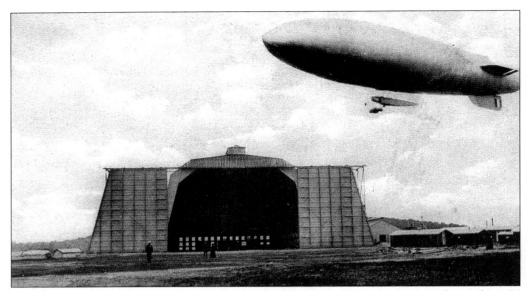

THE CHATHAM NAVAL AIR STATION. The Chatham Naval Air Station was located on 36 acres of land on Nickerson Neck. Hangars for seaplanes and dirigibles, living quarters, a gas holder, a boathouse, a dispensary, repair shops, and a pigeon loft were built. The base was commissioned on January 6, 1918. Two B-class blimps with gondola cars arrived in March in crates. Officers and crews arrived a few weeks later to assemble them. (Courtesy of the Chatham Historical Society.)

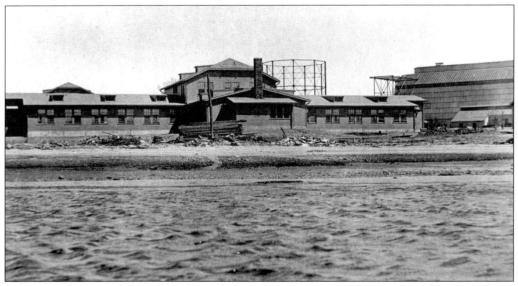

A BASSING HARBOR VIEW. Two barracks were built to house 300 men at the Chatham Naval Air Station in addition to support buildings. The construction had just been finished on the buildings in this photograph. The framework in the center is for the hydrogen gas tank. On the far right is the massive dirigible hangar. (Courtesy of the Chatham Historical Society.)

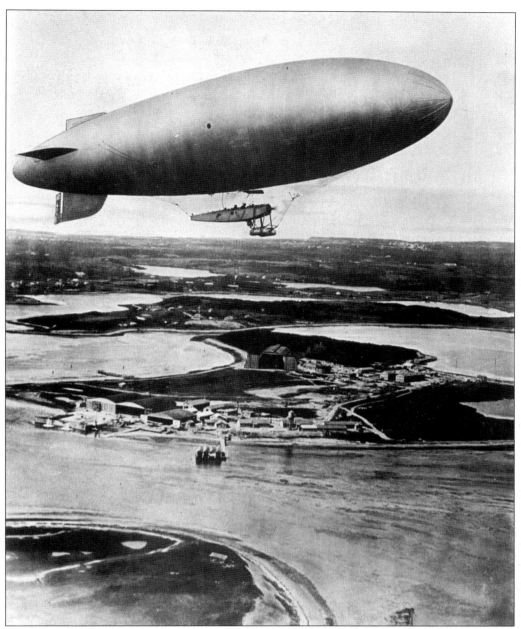

AN AERIAL VIEW. The gondola of the dirigible can be seen clearly. Below and to the right are the twin hangars built for the Curtiss HS-1L flying boats. The smaller hangar next to them was built earlier for the original Curtiss R-9s and the pier and boathouses for 32-foot sea sleds. The open dirigible hangar can be seen farther back. This photograph was taken in 1919. (Courtesy of Linda and George Goodspeed.)

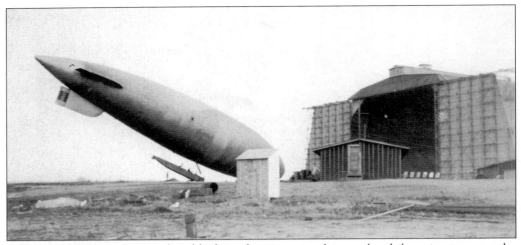

A DIRIGIBLE ACCIDENT. A dirigible from the air station hit a pole while trying to enter the hangar. With a useless rudder, the dirigible was driven 10 miles out to sea. A crew of three men was aboard. A patrol boat rescued the dirigible. Its crew was unharmed, and the $40,000 dirigible was returned in good condition. (Courtesy of the Chatham Historical Society.)

A U-BOAT ATTACK. Within sight of Orleans, the tug *Perth Amboy*, towing four barges, was attacked by a German U-boat and set afire. The submarine then attacked an empty coal barge. Chatham Naval Air Station dispatched all available planes. Although the planes scored no direct hits, they drove the submarine away. (Cartoon from the *Boston Globe*, July 22, 1918.)

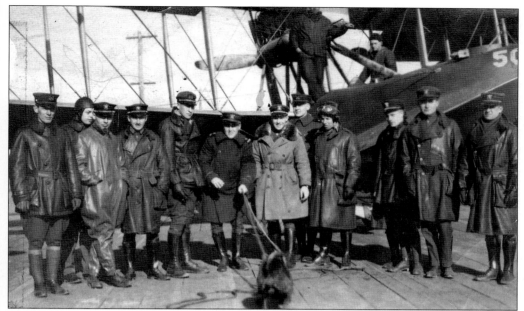

NAVAL AIRMEN. Officers and crew pose in front of an HS-2L seaplane. Standing on the plane are machinist mates Welch and Edwards. Jerry the mascot stands in front of a row of officers from Chatham. From left to right, they are Fisher, Hoopes, Woolsey, Flood, Lange, Cassidy, Hines, Bolin, Weston, Hudson, Brennan, and Krouse. (Courtesy of the Chatham Historical Society.)

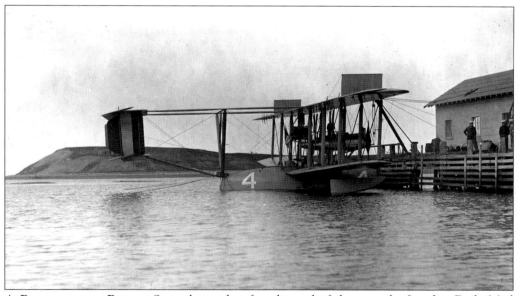

A PRIZEWINNING PLANE. Several months after the end of the war, the London Daily Mail newspaper offered a £10,000 prize to the first aviator to fly between the United States and Great Britain. Although the U.S. Navy was not eligible for the prize, it entered four of its new flying boats built by Curtiss Aviation. Three took off from Rockaway, New York, for Trepassey, New Foundland. (Courtesy of the Chatham Historical Society.)

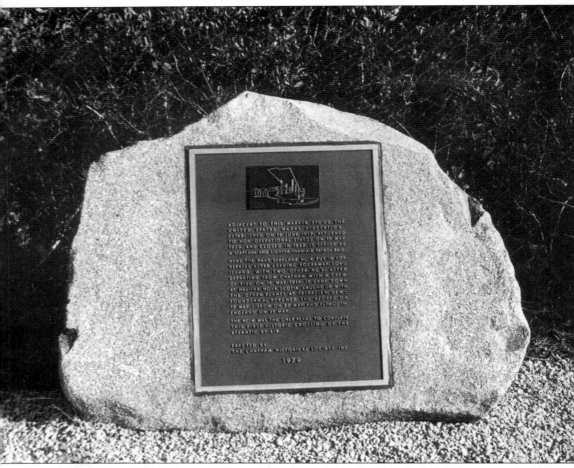

A Chatham NC-4 Marker. One of the planes in the London Daily Mail contest, the NC-4 had engine trouble and was forced to land at sea. The seaplane was towed to Chatham Naval Air Station, where Chief Machinist Mate Grover C. Farris was put in charge. George Goodspeed, a Chatham resident who worked at Bearse's Garage, was called in to assist the repair crew. On May 14, 1919, the NC-4 took off for New Foundland to join the other two planes waiting there. All three took off, but only the NC-4 reached Europe, on May 31, 1919. The Chatham Historical Society erected a monument commemorating this flight in 1979 adjacent to where the Chatham Naval Air Station was located. (Courtesy of the Chatham Historical Society.)

Seven
THE POSTWAR YEARS

*By ones and twos, Chatham's uniformed veterans came home from a world of war,
arriving through late 1945 and well into 1946.*

—Robert D.B. Carlisle, *Weathering a Century of Change*

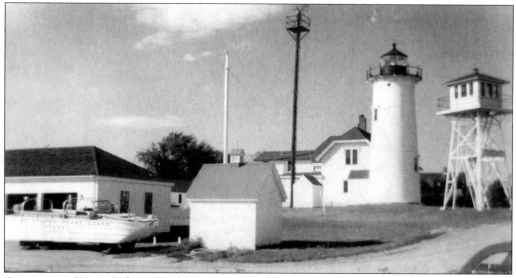

AFTER THE WAR. When World War II ended on August 14, 1945, the bells of the four
churches in town rang, services were held in thanksgiving, and armed service personnel
stationed in Chatham could relax. Guardsmen had patrolled the beaches during the war with
dogs. Spars had kept the then secret Loran going. Soldiers on Great Hill manned radar. Waves
had kept WCC on the air. Remnants of the war remained at Chatham Light—an observation
tower and a DUKW, or amphibious truck. (Courtesy of the Chatham Historical Society.)

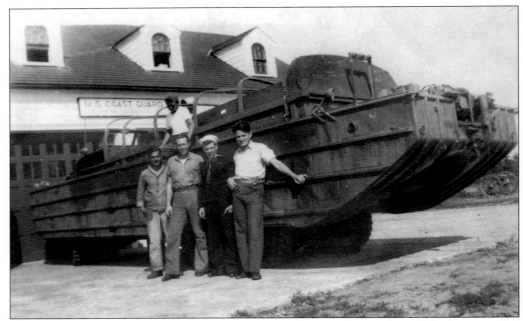

ON MONOMOY POINT. Peace brought a more relaxed mode to military life, but everyday routines continued. People with camps on Monomoy also returned. These Coast Guardsmen are in front of garages where DUKWs, often called "ducks," were kept. These are the vehicles that are used now in Boston and Hyannis for tourist rides on land and sea. (Courtesy of Eileen MacDonald Moore.)

PAINT DUTY. Civilians had been restricted from using their camps on Monomoy for most of the war. When they returned, life had returned to normal. Here two Coast Guardsmen, Dave Monte and Gus Valuzzi, are painting a boat in a maintenance shed at Monomoy Point Coast Guard Station. (Courtesy of Eileen MacDonald Moore.)

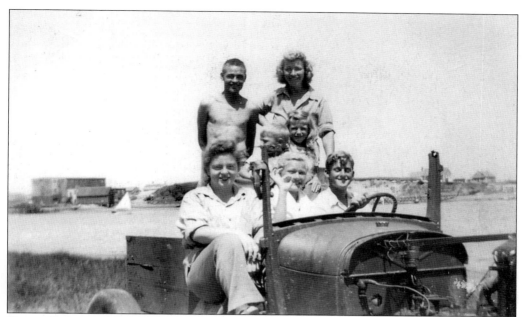

BEACH BUGGIES. Morris Island was no longer connected to the mainland after the war. Old cars were left there for the trek to Monomoy Point. In the front seat are an unidentified woman (left), Floy Rowland Eilers (center), and Carroll Young (at the wheel). Standing in the back are Warren Young (left), Audra Rowland, and her two children Stephen and Franca Rowland. The old freezing plant on Stage Harbor is visible at left. (Courtesy of Floy Rowland Eilers.)

LIFE AT THE LIGHT. By 1946 or 1947, when this photograph was taken, the worries of war had lifted and families were now back on lighthouse property. Tom Crook (left), cousin Tom Perkins (center), and John Crook prove the point. Children's laughter and bicycles replaced guards and dogs. Crook's father served in the U.S. Coast Guard during this time. (Courtesy of the Chatham Historical Society.)

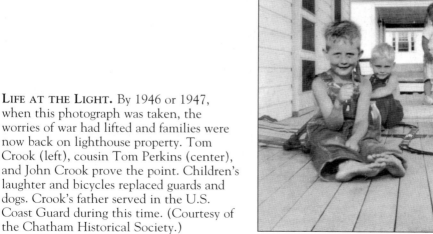

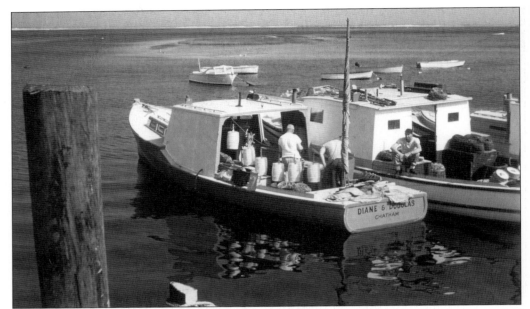

FISHING CONTINUES. During the war, about 20 fishing boats from Chatham kept busy, supplied with ration points for gasoline for their boats and trucks. Bringing home food was in the national interest. After the war, returning veterans swelled the ranks of Chatham's fishing fleet. The *Diane & Douglas* was Frannie Jones's. Crewmen were Tony Cocorro and Butch Young. (Courtesy of the Chatham Historical Society.)

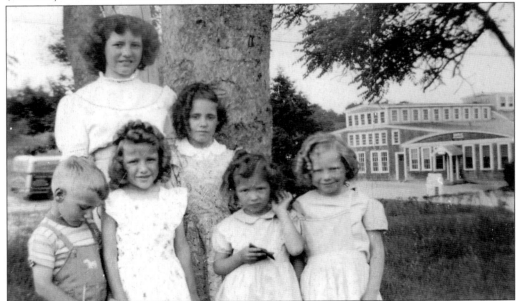

ACME LAUNDRY. An employer and major service for the community, Acme was located near Dr. Floyd and Audra Rowland's home on Frost Fish Creek. Pictured from left to right are the following: (front row) Steven Rowland, Franca Rowland, Verna Liska, and Olivia Liska; (back row) Pudgy and Virginia Liska. Acme was closed in 1970, and a development, Frost Fish Cove, is being built on the site. (Courtesy of Floy Rowland Eilers.)

REPAIRING THE BRIDGE. In October 1949, the Mitchell River Bridge underwent major reconstruction. This view is from the Baker home, now a large yellow structure overlooking the bridge and Stage Harbor. Much of the land across the Mitchell River remains untouched. The Godfrey Mill is clearly visible. (Courtesy of the Chatham Historical Society.)

FROST FISH CREEK. Returning veterans were looking for homes, and the Cape had been discovered. Open space was plentiful. In 1953, a 90-unit subdivision was planned on Fisher Eldredge's old homestead. In 1961, the largest development, Riverbay Estates, was begun with one-acre lots overlooking Muddy River selling for $11,000. (Courtesy of Floy Rowland Eilers.)

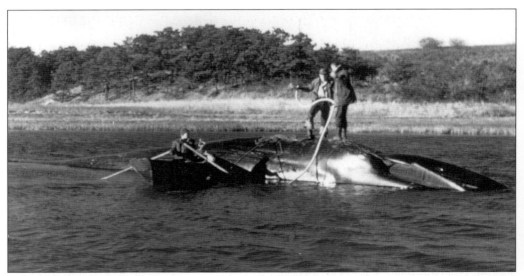

THAR SHE BLOWS! When this whale was towed into Frost Fish Creek, it was a definite attraction. Within a few days, it caused quite a stink. The whale had beached in Wellfleet in a 1945 storm and was removed by Dr. Floyd Rowland to salvage the oil, skeleton, and so on. Salvagers include Richard Liska and Gene and Ross Rowland. (Courtesy of Floy Rowland Eilers.)

NEW FIRE ENGINES. In 1945, Chatham had 1,315 dwellings. By 1950, development had increased the number of homes substantially. To serve the needs of a larger number of homes, the Chatham Fire Department began acquiring new fire trucks. Engine No. 1 had a 1949 chassis, but this Ford F-8 was delivered to Manson's dealership in 1950. George Goodspeed, head mechanic at Manson Ford and chief of the fire department, is on hand. Below, another new fire truck is delivered to the Chatham Fire Department. The garages in back of the new truck are the same in use today on Depot Road. From left to right are Walden Bearse, Harold Eldridge, Merrill Doane, and an unidentified salesman. (Above courtesy of Linda and George Goodspeed; below courtesy of Fred H. Bearse.)

CHATHAM'S FIREFIGHTERS. The combined crews of Chatham's fire stations pose with two of the town's fire engines. From left to right are the following: (front row) Wilbur Cahoon, Elisha Bearse, Daniel E. Howes, unidentified, Winston Nickerson, Tyler Atwood, Elmer Sampson (assistant chief), and George Goodspead (fire chief); (back row) Cyril Cahoon, unidentified, C.H. Cahoon, unidentified, Cyrus Baker, unidentified, Robert Tuttle, Victor Chase, Edwin Eldredge, Merrill Doane, Parker Romkey, Clement Eldridge, unidentified, Ernest Eldredge, Zenas Kendrick, and Joe Eldridge. (Courtesy of Linda and George Goodspeed.)

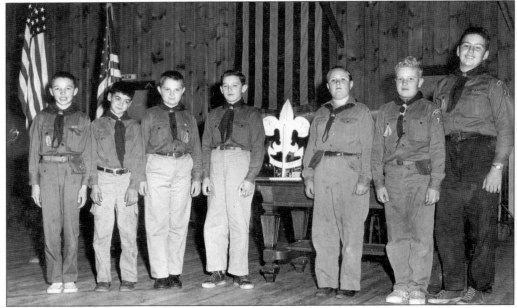

BOY SCOUTS. This troop poses *c.* 1950 in the Chatham Community Building, built in 1947. From left to right are George Mettus, unidentified, Richard Kelsey, Fred H. Bearse Jr., Richard Eldridge, Robert Jordan, and Gordon Baker. In later years, the Boy Scouts would move to the Doc Keene Scout House on Stage Harbor Road. Now undergoing renovation, scouts are meeting in makeshift quarters now. (Courtesy of Fred H. Bearse.)

THE CAHOON HOME. Ruby Nickerson married Arthur M. Cahoon, and they lived in this house on Main Street in South Chatham most of their married life. The house is still standing, and the stained-glass window visible in the right foreground is a distinguishing element. Many of the old South Chatham homes remain almost as they were when built. (Courtesy of the Nickerson Family Association.)

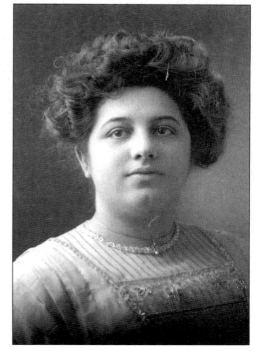

RUBY NICKERSON CAHOON. A descendant of Chatham's founder William Nickerson, Ruby Cahoon was born in 1883 and died in 1954. During that time, she witnessed most of the ordinary and extraordinary events recorded in this book. South Chatham, which experienced the least development after World War II, was one constant in her life. (Courtesy of the Nickerson Family Association.)

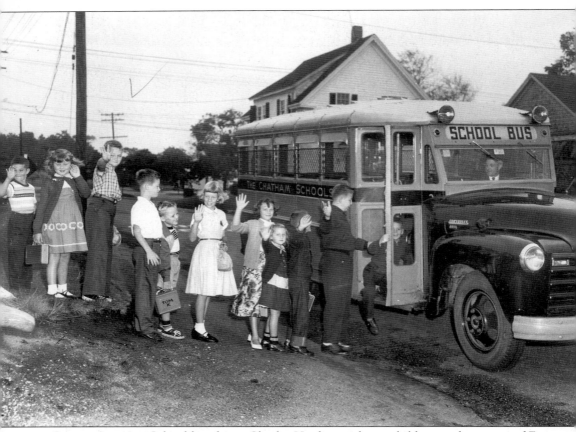

OFF TO SCHOOL. School bus driver Charles Harding picks up children at the corner of Forest Beach Road and Main Street in South Chatham. From left to right are Richard Silva, Jane Marguit, Richard Kelsey Jr., Matt Hart, Tom Kelsey, Beth Eldridge, Hazel Robie, two unidentified, Gordon Baker, and Bob Baker. The children boarding the bus were headed for the Main Street School, which had begun to feel the space crunch from the emerging baby boomers. In 1950, 10 more classrooms were added to Main Street School, as well as a shop and an auditorium-gymnasium. By 1953, the school had 503 students. A new school was needed. The Depot Road Elementary School for kindergarten through third grade was built. In 1959, 724 students were enrolled in both schools. In 1961, the superintendent of schools said a new high school was needed. At the March 5, 1962 town meeting, it was voted to spend $1.3 million for the construction. Now a middle school and high school, it is located on Crowell Road. (Courtesy of Fred H. Bearse.)

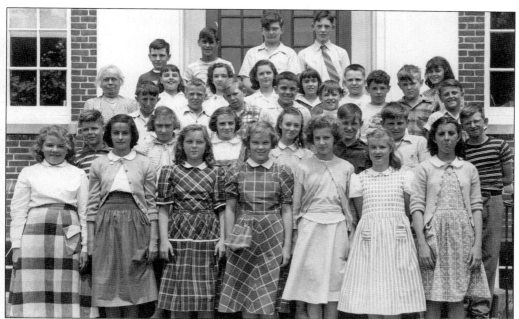

SCHOOL IN THE 1950S. Mary Ella Ellis, a petite teacher in the Chatham schools, was a large presence in the classroom. She taught from 1921 to 1956. Above, the Class of 1956 is on the front steps of the Main Street School. From left to right are the following: (first row) Priscilla Jordan, Frances Masachi, Diane Kelley, Betty Jane Kendrick, Cora Stacy, Margaret Langton, and Shirley Lenia; (second row) Ralph Landry, Arlene Hanson, Carol Reynolds, Helen Langton, unidentified, Bart Dunbar, and Ed Zibrat; (third row) Eugene Stepbus, Donald ?, Joe Liska, Rusty Sylva, Kenneth Doane, George Goodspeed, Dick Buck, and Ralph Nickerson; (fourth row) Mary Ella Ellis, Louise Bassett, Audrey Matteson, Betty Landry, Martha Belle Chase, Ed Hopkins, and unidentified; (fifth row) Colin Stevenson, unidentified, Hillard Gordon, and Ronald Sigafus. Below, the Class of 1959 is at the side entrance to the school. Linda Bearse Goodspeed is second from right in the front row. Mary Ella Ellis is in the middle row, center. John Rodericks is in front of her in the white shirt. (Courtesy of Linda and George Goodspeed.)

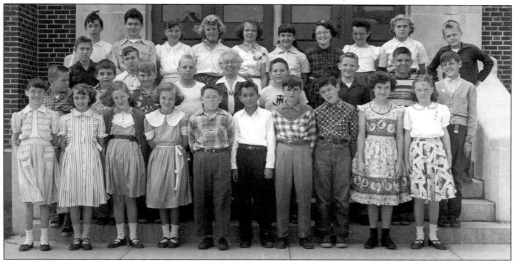

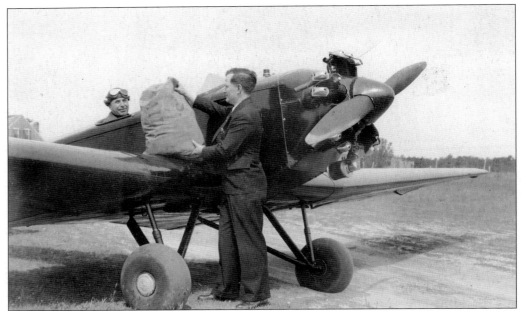

A CHATHAM AIRMAN. Wilfred Berube was introduced to Chatham *c.* 1910, when his employer summered on the Mill Pond. In 1928, he got his pilot's license and, shortly after, bought 72 acres off George Ryder Road. After the war, Berube established his Chatham Flying Services there, using his mechanic's expertise and pilot's skills. Pictured is postmaster Paul W. Roth taking airmail from the plane. (Courtesy of Linda and George Goodspeed.)

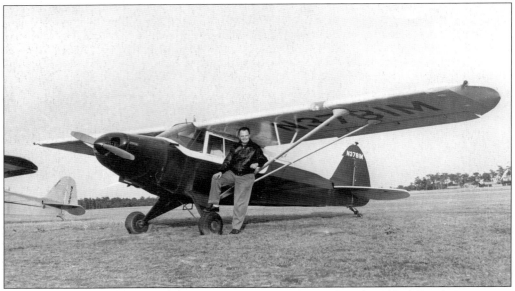

PHOTOGRAPHER RICHARD KELSEY. In 1951, the town purchased Wilfred Berube's property and named it the Chatham Municipal Airport. Many Chathamites learned to fly there. Photographer Richard Kelsey—known for his aerial views of Cape Cod and for traditional photography that included public events and private celebrations in Chatham—poses next to his 1947 Piper PA12 super cruiser. (Courtesy of Fred H. Bearse.)

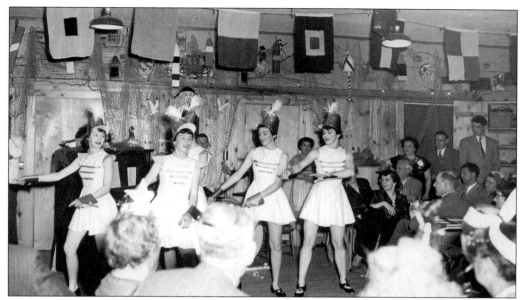

SILVER CIRCLE CABARET. During the 1950s, South Chatham was home to an energetic group of young families who used the South Chatham Village Hall as a community center. Each year, special shows were put on, at which locals entertained each other. Here Chatham's answer to the Rockettes dances away. They are, from left to right, Joan Ruggles, Jane Tuttle, Nancy Ryder, and Diane Stevenson. (Courtesy of Linda and George Goodspeed.)

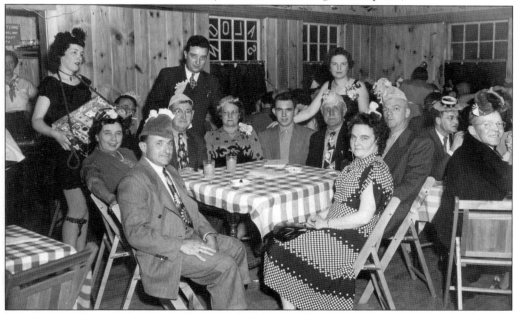

THE SILVER CIRCLE SALOON. This crowd of South Chathamites is at the South Chatham Village Hall for more fun. From left to right are the following: (front row, sitting) Nora and George Loomis, Benjamin and Alice Bearse, Bob Clark, Pa Clark, and Margaret and Al Clark; (back row, standing) Bonnie Hart (cigarette girl) and Norman F. and Gertrude Clark Bearse. (Courtesy of Linda and George Goodspeed.)

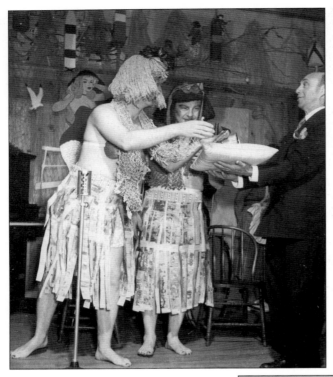

A TROPICAL TWOSOME. The Silver Circle entertainments engrossed those involved, from coming up with the ideas and music to costumes and performing. Linda Goodspeed could not wait to see the entertainments, especially when adults set themselves up for laughter. Here, two hula dancers dressed in newspaper skirts try to bring Whit Tileston into the act. (Courtesy of Linda and George Goodspeed.)

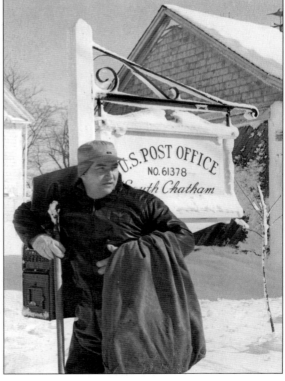

WAITING IN THE COLD. South Chatham was stopped in its tracks by a snowstorm in 1953. South Chatham postmaster Fred H. Bearse waits for the mail delivery. It did not arrive for two days, and that was late in the afternoon, just about the time the milk and bread trucks got through. Road-clearing help came from as far away as snowblowers from the Berkshires. (Courtesy of Fred H. Bearse.)

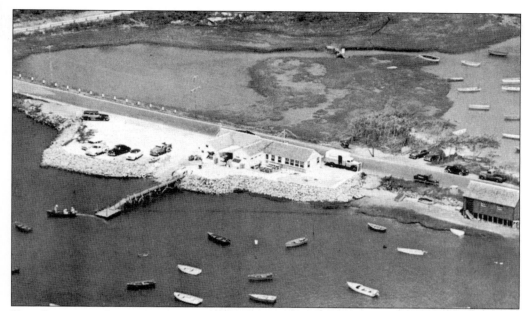

THE CLAM AND LOBSTER BAR. In the 1950s, there was a seaside restaurant on Bridge Street just down from the Mitchell River Bridge. It was open for lunch and dinner and had "wonderful native seafood," according to many. Run by Chet and Ruth Hackett, the restaurant became a weekly event for some families who went out to lunch or dinner there. (Courtesy of Floy Rowland Eilers.)

LOBSTER ANYONE? Audra Rowland, who was a cook and also a manager at the Clam and Lobster Bar, selects a lobster from a tank behind the restaurant. In later years, Rowland was the "flower lady" whose bouquets were sold from a street-side case at Rowland Drive. The Monomoy Yacht Club now occupies the second floor of the building, which is a marine products store. (Courtesy of Floy Rowland Eilers.)

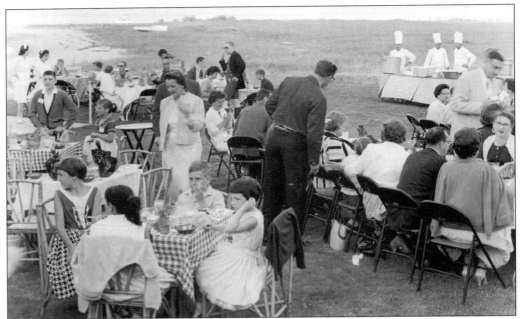

A Chatham Bars Inn Clambake. Since it opened its doors, the Chatham Bars Inn has held clambakes. In the 1950s, the inn began to cater to ever more families with children. This beachside clambake is taking place where the pool and tennis courts are now located. Note the chefs in the background on the right with tall white hats, large vats, and serving dishes. (Courtesy of the Chatham Bars Inn.)

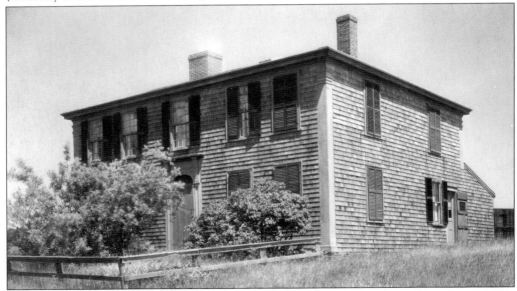

The Christopher Ryder House. This photograph from 1935 shows a very old home in sad shape. By June 1954, the house had been renovated and turned into one of the top restaurants in the country. Run by Bud and Louise Kastner, it earned four stars from the *Mobil Travel Guide*. An opera house was added in 1962 for after-dinner entertainment. (Courtesy of the Chatham Historical Society.)

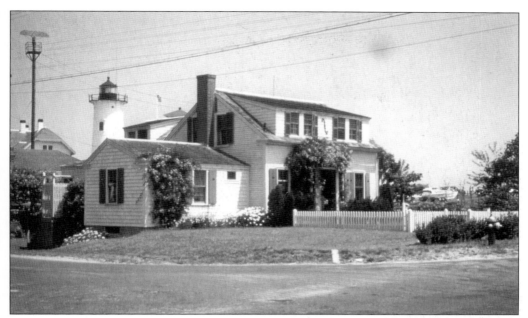

THE MALLOWS HOUSE. Many Chatham homes were built in one location and then moved. This c. 1815 home originally sat where the Chatham Beach and Tennis Club is. Moved across the street, south of Chatham Light, it was turned a quarter of the way around in 1938 to face Bridge Street for more sunlight and a better view. (Courtesy of the Chatham Historical Society.)

CLAFLIN LANDING. This quiet scene is Claflin Landing c. 1954. Much of the beach has been lost in this area, but the same vista of boats, sun, and sky remain for today's visitors to enjoy. The 1987 break in North Beach severely changed the shoreline from the lighthouse back to the Fish Pier. (Courtesy of Floy Rowland Eilers.)

A Dinghy and Ducks. Ducks continue to ply the waters of Pleasant Bay, and dinghies are drawn up on shore all along its coastline. This quiet scene is looking north over Frost Fish Cove. Much of the hill on the far side of the creek is dotted with homes from Cove Hill development. Wetlands in some areas are now conservation lands. (Courtesy of Floy Rowland Eilers.)

The Liska Brothers. Amon Liska (left), a fisherman often called Captain Ahab because of his peg leg, was originally from Oregon. Amon moved to Chatham and lived with his wife, Hester, in a house on Rowland Drive. He is shown with brother Ernest, who is visiting from Oregon. Both were Audra Rowland's brothers. (Courtesy of Floy Rowland Eilers.)

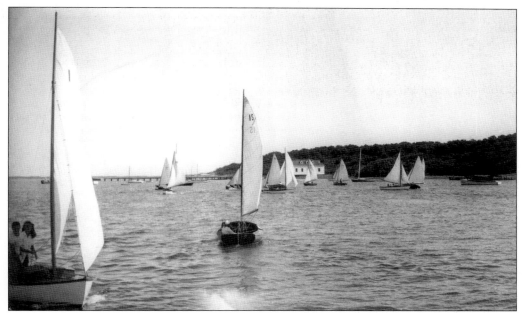

THE STAGE HARBOR YACHT CLUB RACE. Founded in 1932, the club built up a large fleet, including Sprites, 420s, and day sailers. Children were taught everything about sailing from knots and boat parts to skippering. The older Chatham Yacht Club has a dock and anchorages at Eastward Ho. The newest Monomoy Yacht Club was formed in 1937 and is quartered over Stage Harbor Marine. (Courtesy of the Chatham Historical Society.)

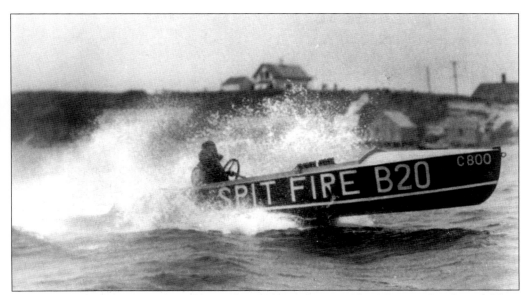

POWERBOATS. This *c.* 1940 speedboat is being driven by Fire Chief George Goodspeed. Note the name *Spit Fire*. Where sailboats once held sway, powerboats are the dominant type on the waters surrounding Chatham. Stiff currents and treacherous bars that call for an engine are the reasons more people are using powerboats. Fishermen, of course, rely on powerboats to reach the fish. (Courtesy of Linda and George Goodspeed.)

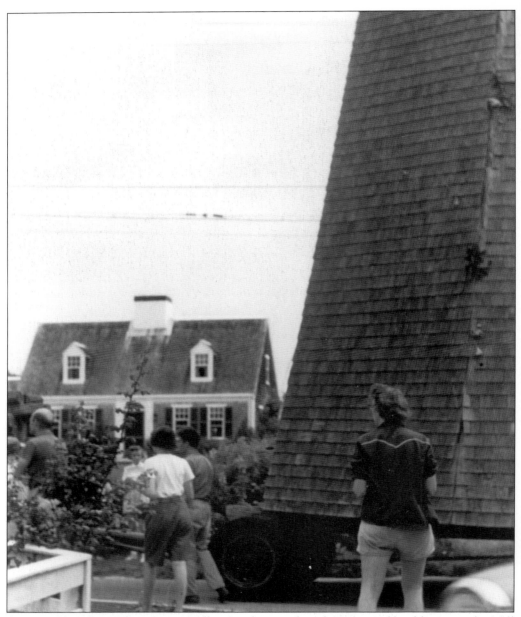

A Mill Goes By. When Stuart Miller Crocker purchased 12 acres of land between the Mill Pond and Stage Harbor Road, he also acquired Benjamin Godfrey's 1797 gristmill. Crocker asked the town if they would like to have it and relocate it. At the 1955 town meeting, it was voted to accept the gift, and funds were provided to move it. Here it is on its journey to Chase Park. (Courtesy of the Chatham Historical Society.)

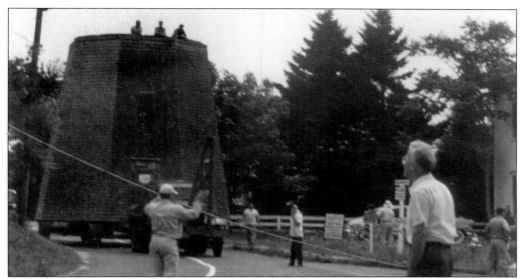

MAKING WAY. Moving a gristmill requires some intricate planning. Here the mill, now in two parts, is being driven down State Harbor Road. Utility crews make sure all wires that may be snagged are temporarily taken down for the mill's passing. Traffic has to be detoured as the lumbering mass makes its way around the corner. (Courtesy of the Chatham Historical Society.)

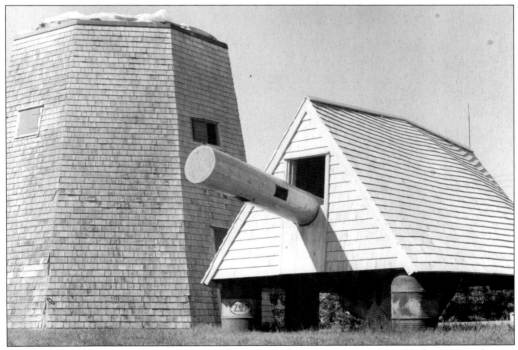

AN ANTIQUE IN TWO PARTS. The 1797 gristmill has arrived in Chase Park, its new home. Now it has to be reassembled to become once more a working mill. Its location in Chase Park still has it overlooking the Mill Pond, but from a location nearer to the town center. It was put together and ready for visitors in summer 1956. (Courtesy of the Chatham Historical Society.)

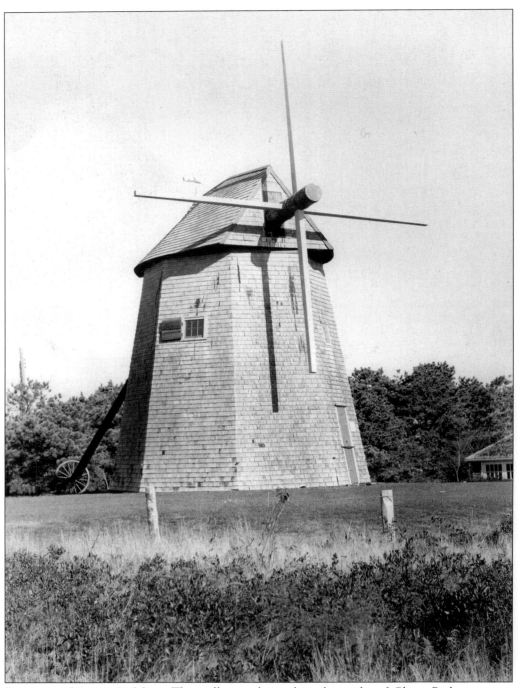

BENJAMIN GODFREY'S MILL. The mill, now located in the midst of Chase Park, is a very popular attraction. Chase Park, in which it sits, was the gift of Avis Chase. On her death, she gave the town a 3.5-acre site southeast of Cross Street for a public park. She hoped it would be named Chase Park in memory of her late husband, Capt. Silmon Chase. (Courtesy of the Chatham Historical Society.)

THE RETIRED MEN'S CLUB. These six men are the founders of one of Chatham's most popular institutions, the Retired Men's Club. From left to right are Chester Eldredge, "Fuzzy" Frizell, Lou Webster, Frank Brewin, Ted Bigelow, and Frank Love. Every Friday afternoon, the club meets for coffee, doughnuts, and a speaker at St. Christopher's Episcopal Church. There are coffee cups in the photograph, but no doughnuts are in sight. (Courtesy of the Chatham Historical Society.)

THE CONSERVATION FOUNDATION. Gov. John Volpe of Massachusetts displays a certificate establishing the Chatham Conservation Foundation in 1962. From left to right are Hastings Keith, state representative; Peter Grey, first treasurer; John Manson, first president; Gov. John Volpe; and Frank Love, first vice president. The foundation's main concerns include the protection of watershed resources and preserving open spaces. (Courtesy of the Chatham Historical Society.)

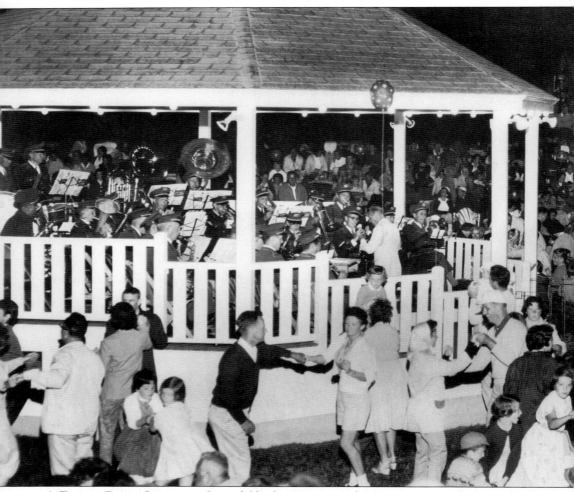

A FRIDAY BAND CONCERT. One of Chatham's most enduring events is its Friday night band concerts in Kate Gould Park in the summer. The bandstand holds the Chatham Band, conducted by Whit Tileston. Couples and children dance to the music in gay abandon. The band is an outgrowth of the American Legion Band of the 1930s. With the leadership of George Goodspeed, Alexander Griffen, and others, a town band was formed with Thomas Nassi as its conductor. Nassi was an Albanian who had composed his country's national anthem. He was also the music teacher and conducted the high school band. The band, which was on a sabbatical during the war years, was revitalized in 1946. It needed a new leader and, in 1946, Webster Whitney "Whit" Tileston, fresh from the service, took over. He finished the 1994 season as its leader and died five months later at 89. Kate Gould Park is named for the woman who donated the land to the town. She was a librarian and Gould's family owned properties where the present park is located. She had the buildings demolished and donated the land to the town for a park. (Courtesy of the Chatham Historical Society.)

Eight
CHATHAM'S 250TH ANNIVERSARY

I didn't want to be on the float. I wanted to be in the parade.
So I went on both sides of the street, back and forth, back and forth.
Everyone saw me and I had the time of my life.

—Marcella Daniels, *Memories for the Millennium*

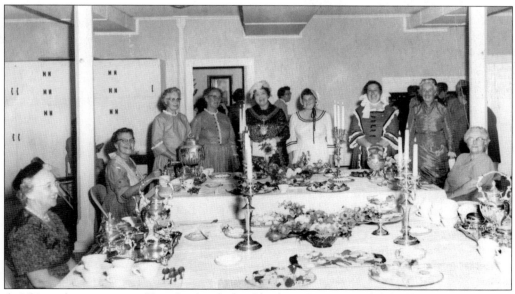

A 250TH ANNIVERSARY TEA. In April, the Chatham Woman's Club held a tea in honor of Mrs. John Grievson, madame mayor of Chatham, England, shown standing with her ceremonial necklace. All the other women standing with the mayor are dressed in "early settler" costumes. The tea was held in the Congregational church and was one of the kickoff events for the 250th anniversary celebration. (Courtesy of the Chatham Historical Society.)

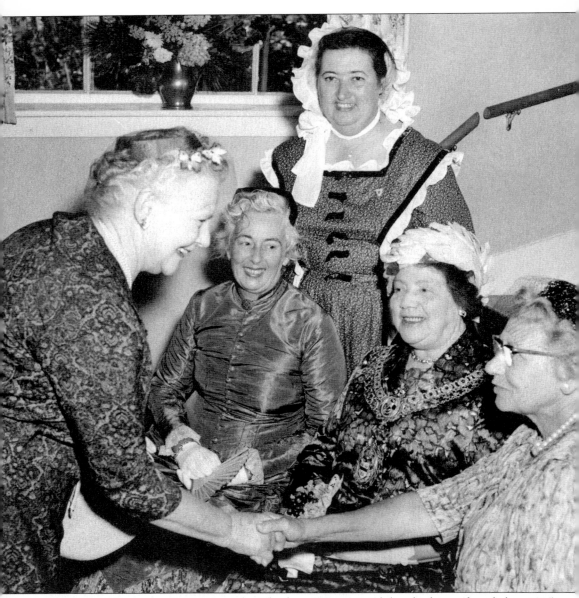

CHATHAM, ENGLAND'S MAYOR. The Chatham Woman's Club, which was founded in 1915, played host to Mrs. John Grievson at a tea during her stay for the 250th anniversary celebrations. She was the guest of honor at numerous events. Grievson, resplendent in her necklace of office, is shown with Chatham Woman's Club president Marcella Daniels, standing behind the mayor, who is wearing one of two outfits she made for the anniversary celebrations. Mrs. Harold Tuttle, seated to the left of the mayor, is also attired in a period costume. Her husband was chairman of the town's anniversary committee. Mrs. George L. Mentley, on the far left, shakes hands with Mrs. Charles E. Shepherd, president of the Massachusetts Federation of Women's Clubs, who came bringing greetings to the town. (Courtesy of the Chatham Historical Society.)

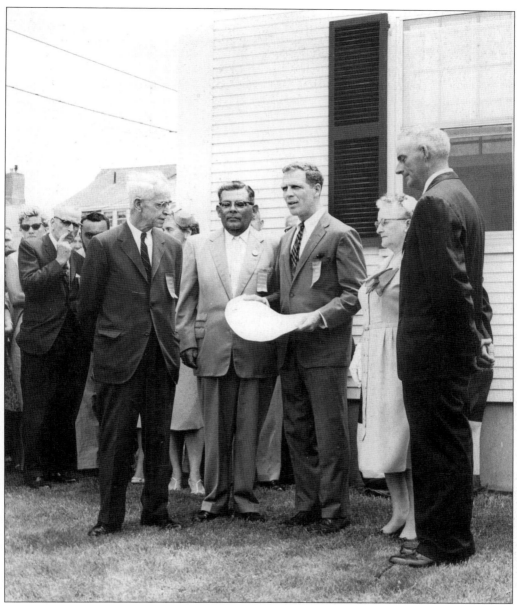

GREETINGS. Kevin White, secretary of the Commonwealth of Massachusetts, presents a certificate and greetings from the governor on June 11, 1962. From left to right are Bob McNeece (selectman), Everett Small (selectman), Kevin White (holding the certificate), Mabel Nichols (town clerk), and Dave Ryder (selectman). In the back on the left is Harold Tuttle, chairman of the anniversary celebration. (Courtesy of the Chatham Historical Society.)

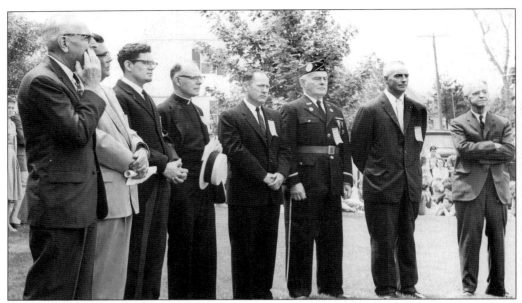

JUNE 11, 1962. Town leaders gathered at the Chatham Town Hall to mark the 250th anniversary of Chatham's incorporation as a town. From left to right are Harold Tuttle, anniversary celebration chairman; Everett Small, selectman; unidentified; Father Brennan, Holy Redeemer's pastor; Paul Carr, town treasurer; Sam Cobb from the American Legion; Dave Ryder, selectman; and Bob McNeece, selectman. (Courtesy of the Chatham Historical Society.)

A TIME CAPSULE. Part of the June 11, 1962 festivities was the assembling and burying of a time capsule. Here, South Chatham postmaster Fred H. Bearse tells the gathering what items are being included, as James Shepherd and Ann Tuttle put them into the container. Harold Tuttle, Kevin White, Mabel Nichols, and Father Brennan look on. (Courtesy of Fred H. Bearse.)

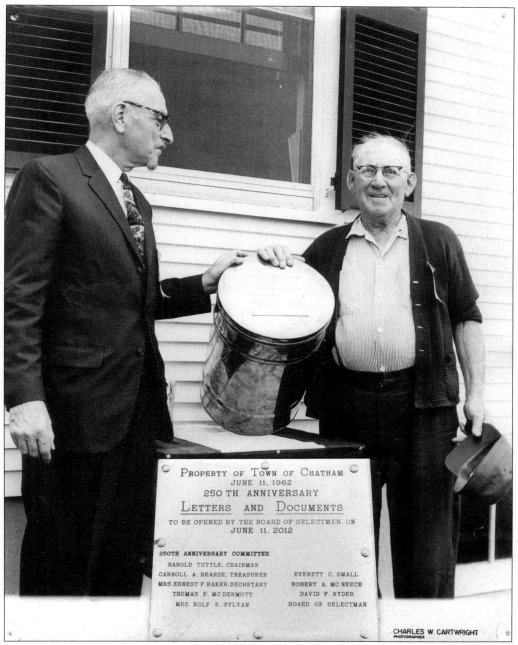

OPEN ON JUNE 11, 2012. Harold Tuttle, chairman of the 250th Anniversary Committee, and Chester Eldredge display the sealed time capsule containing letters and documents to be opened by the board of selectmen on June 11, 2012. Other members of the committee were Carroll A. Bearse, Mrs. Ernest F. Baker, Thomas P. McDermott, and Mrs. Rolf E. Sylvan. There were 45 different committees and groups that planned and delivered four months of memorable commemorative activity during 1962, marking the 250th anniversary of Chatham's incorporation as a town. (Courtesy of the Chatham Historical Society.)

BEARDED, SWIMSUIT-CLAD BAND MEMBERS. Four members of the brass section of the Chatham Band are shown after entertaining the townsfolk on Main Street. They are, from left to right, Willard Nickerson (saxophone), Joseph A. Nickerson (clarinet), Benjamin K. Goodspeed (trumpet), and Philip G. Nickerson (trombone). All the men in town were encouraged to grow beards for the celebration. Those who did not were "arrested." (Courtesy of the Chatham Historical Society.)

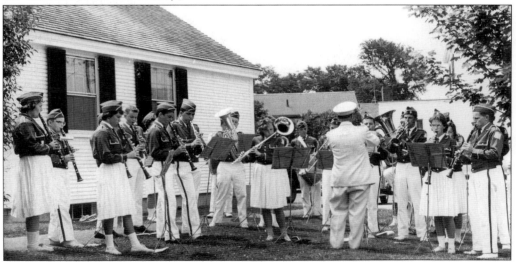

CHATHAM HIGH SCHOOL BAND. Band leader Whit Tileston, with his back to the camera, leads the Chatham High School Band during the 250th anniversary festivities on June 11, 1962. Tileston for many summers also led the Chatham Town Band during its Friday evening concerts in Kate Gould Park. (Courtesy of the Chatham Historical Society.)

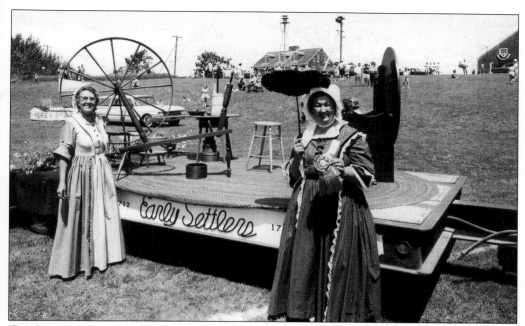

THE JULY 4, 1962 PARADE. The 250th anniversary celebrations ended with the town's annual Fourth of July parade. Pictured is the Chatham Woman's Club float, which won a blue ribbon. Entitled *Early Settlers,* it exhibited a spinning wheel and old furniture. Mrs. Charles W. Cartwright and Mrs. Gerald Daniels are wearing authentic-style dresses of the 18th century. (Courtesy of the Chatham Historical Society.)

THE HISTORICAL SOCIETY FLOAT. South Chatham postmaster Fred H. Bearse, resplendent in Lincolnesque beard and top hat, is shown with the society's float featuring the Atwood House Museum. The jeep must be from a summer resident. Note the "NH" (for New Hampshire?) on the Connecticut license plate. Bearse won the ribbon hanging from his jacket but cannot remember why. (Courtesy of Fred H. Bearse.)

THE END. The parade was just one of many events celebrating the 250th anniversary of Chatham's incorporation as a town in 1712. After it was over, these two participants still felt like dancing. Dressed as early settlers, Chatham Woman's Club president Marcella Daniels, complete with parasol, takes the hand of South Chatham postmaster Fred H. Bearse. The Jeep in the background, the Chatham Historical Society float, carries a replica of the Atwood House Museum on its roof. Everyone in Chatham took part. How will the 300th anniversary celebration shape up? Perhaps Chatham's founding father William Nickerson's own words will be an inspiration. "We may go on in a way of peace and love, for the glory of God, and the good and welfare of the government, and the enlargement thereof, and the good of one another." (Courtesy of Fred H. Bearse.)